CENTRAL LEEDS
HISTORY TOUR

First published 2021

Amberley Publishing
The Hill, Stroud,
Gloucestershire, GL5 4EP
www.amberley-books.com

Copyright © Paul Chrystal, 2021
Map contains Ordnance Survey data
© Crown copyright and database
right [2020]

The right of Paul Chrystal to be
identified as the Author of this work
has been asserted in accordance with
the Copyrights, Designs and Patents
Act 1988.

ISBN 978 1 3981 0189 0 (print)
ISBN 978 1 3981 0190 6 (ebook)

All rights reserved. No part of this
book may be reprinted or reproduced
or utilised in any form or by any
electronic, mechanical or other means,
now known or hereafter invented,
including photocopying and recording,
or in any information storage or
retrieval system, without the permission
in writing from the Publishers.

British Library Cataloguing in
Publication Data.
A catalogue record for this book is
available from the British Library.

Origination by Amberley Publishing.
Printed in Great Britain.

PREFACE

This is a handy, inexpensive and portable tour of the best bits of history to be found in the city of Leeds. It is made up of places and people that best represent the city's heritage, and these have been selected from my five books on the city. So, in short, it is a kind of 'best of', which can be read straight through, dipped into, or taken with you on a tour of Leeds, taking in all of the stops or just a selection.

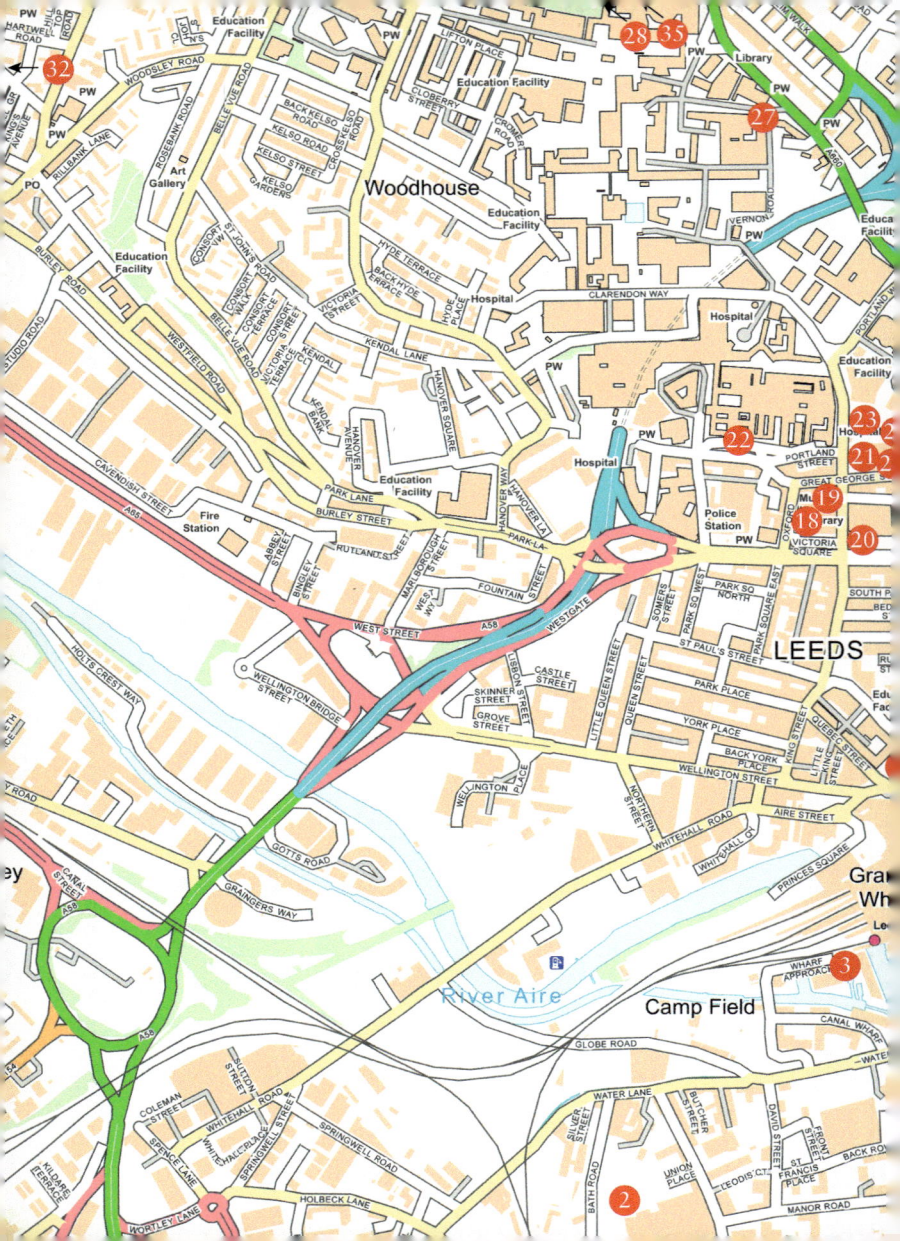

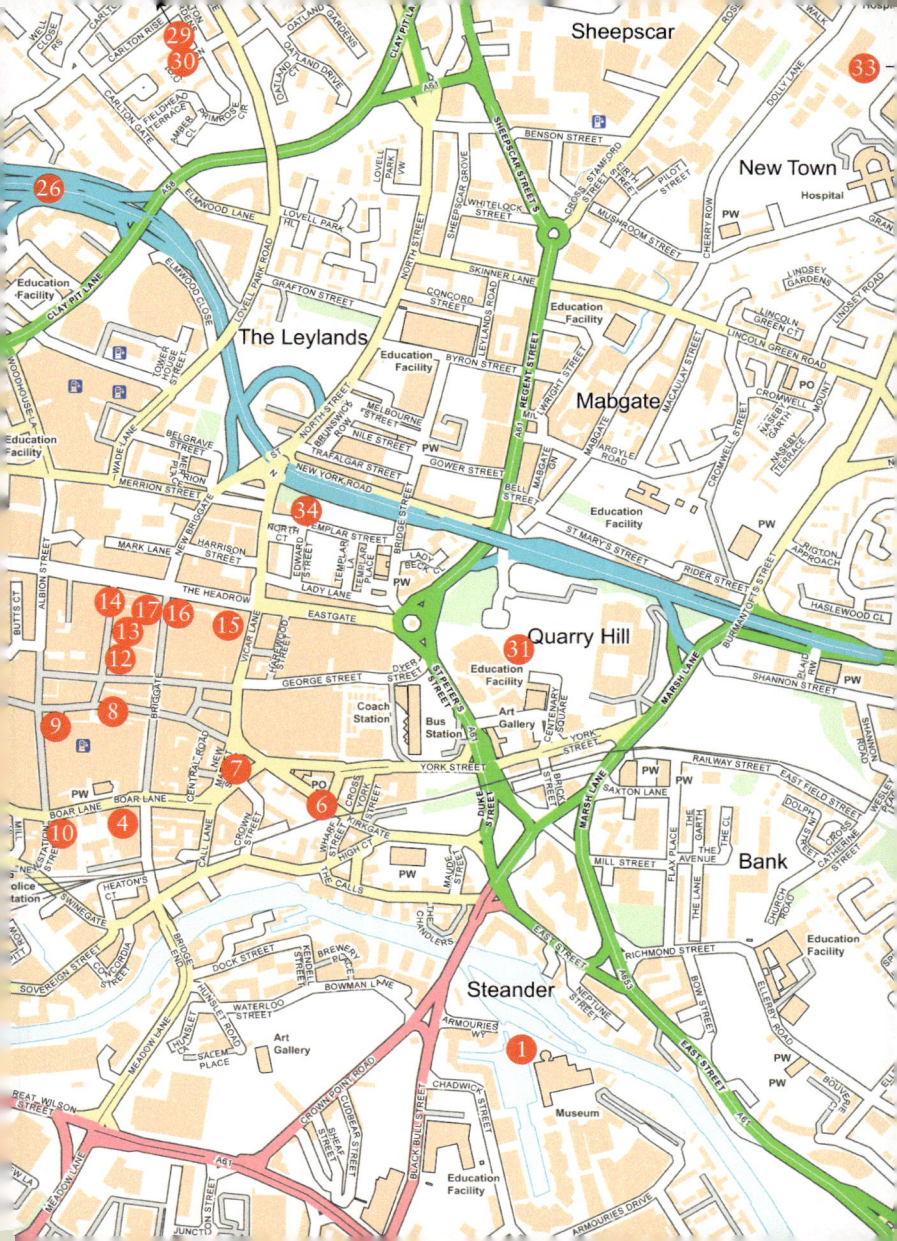

KEY

1. Royal Armouries Museum (1996), Armouries Drive, Clarence Dock
2. Temple Works
3. The Canal and the Dark Arches
4. Time Ball Buildings, Briggate
5. The Black Prince
6. The White Cloth Hall (1711), Kirkgate
7. The Corn Exchange, Call Lane
8. The Bread Arch, Commercial Street
9. The NAAFI Club and Leeds Library
10. Chickens in Boar Lane
11. The Griffin, Boar Lane
12. Whitelock's Ale House, Turk's Head Yard, off Briggate
13. The Pack Horse, off Briggate
14. City Varieties Music Hall, Swan Street, off Briggate
15. County Arcade, 1907
16. Thornton's Arcade (1878), Victoria Quarter, off Briggate
17. Three Legs Inn Yard
18. Leeds Town Hall (1858), The Headrow
19. Hoping on the Town Hall Steps: The Second British Esperanto Congress, 1909
20. Leeds Art Gallery (1888), The Headrow
21. The Victoria Family & Commercial Hotel, Great George Street
22. Leeds General Infirmary
23. The Mechanics' Institute (now City Museum)
24. Dorothy Una Ratcliffe
25. Leeds City Museum (1819), Park Row and Millennium Square
26. *The Yorkshire Post* Building
27. Brotherton Library, Leeds University
28. The Hyde Park Picture House, Brudenell Road
29. Leeds Workhouse
30. Thackray Medical Museum (1997), Beckett Street
31. Quarry Hill Flats, 1939
32. Air-raid Luxury in Burley
33. Barnbow Lasses
34. Attention!
35. Instantly Detached

INTRODUCTION

It is the Venerable Bede who provides our introduction to the settlement of Leeds. This first record is found in his *Historia Ecclesiastica* (Book 2, Chapter 14), written around AD 731, where he describes an altar from a church built by Edwin of Northumbria in 'the region known as Loidis', a Welsh-speaking subdivision of Elmet that was later a part of the kingdom of Northumbria. 'Leodis' may mean 'people of the flowing river', the river being the Aire on which Leeds stands. A reference to 'Ledes' also appears in the Domesday Book (1086).

After the Norman Conquest, Leeds was spared the devastation and depredation of the rapacious Harrying of the North by William I. Apart from the evidence within *The Annals of Yorkshire* (1862), *The Leeds Guide* of 1837 states that Ilbert de Lacy built a castle around 1080 on Mill Hill – today's City Square – that was besieged by Stephen on his way to Scotland in 1139. The castle occupied the site surrounded by Mill Hill, Bishopgate, and the western part of Boar Lane. According to the *Hardynge Chronicle* in 1399, Richard II was imprisoned at Leeds before being moved to Pontefract for execution.

In 1207, Leeds received its first charter, leading to a new town being laid out along one street, overseen by Maurice de Gant, lord of the manor. This was Brigg Gata, later named Briggate ('brycg' is the Old

English for 'bridge', and *gata* is Old Norse for 'way' or 'street'), which was wide enough to support a bustling market. The poll tax of 1379 reveals that the population was less than 300, making Leeds one of the smallest towns in Yorkshire – Snaith, Ripon, Tickhill and Selby were larger. Agriculture was still the principal economy here and the Tudors saw Leeds become an established cloth-trading town. In 1536, the traveller and poet John Leland described Leeds as 'two miles lower than Christal [Kirkstall] Abbey, on Aire river, a praty [pretty] market town which stondith most by clothing having one paroche churche reasonably well buildid and was as large as Bradford, though not so quik'. Not so quik meaning not as commercially sharp.

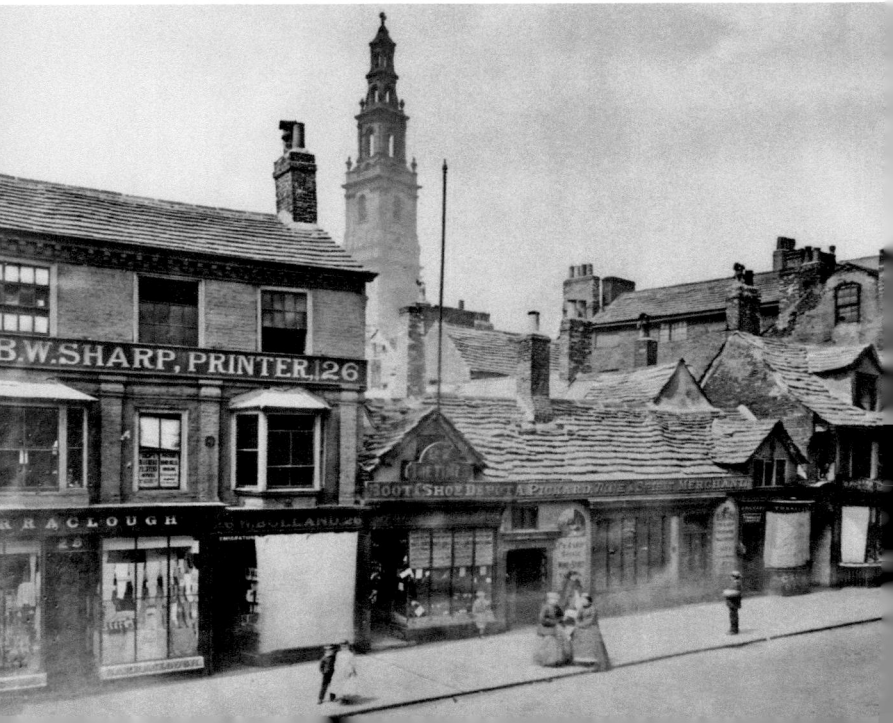

The fearless Celia Fiennes visited Leeds and, although she seemed more preoccupied with the price and strength of beer and whether her cheese sandwich should be on the house or not, she provides a contemporary picture of the town:

> Leeds is a Large town, severall Large streetes, Cleane and well pitch'd and good houses all built of stone ... This is Esteemed the Wealthyest town of its bigness in the Country its manufacture is ye woollen Cloth-the Yorkshire Cloth in wch they are all Employ'd and are Esteemed very Rich and very proud ... here if one Calls for a tankard of Ale wch is allwayes a groate it's the only dear thing all over Yorkshire, their ale is very strong ... but for paying this Groat for your ale you may have a slice of meate Either hott or Cold according to the tyme of day you Call, or Else butter and Cheese Gratis into the bargaine; this was a Generall Custom in most parts of Yorkshire but now they have almost Changed it, and tho' they still retaine the great price for the ale, yet Make strangers pay for their meate, and at some places at great rates, notwithstanding how Cheape they have all their provision ... This town is full of discenters, there are two Large meeting places, here is also a good schoole for young Gentlewomen; the streetes are very broad, the Market Large.
>
> *Through England on a Side Saddle in the Time of William and Mary* (1698)

A few years later Daniel Defoe, in his *A Tour Through the Whole Island of Great Britain*, agrees (although he is not so obsessed with the beer and bar meals on offer) and provides a meticulously detailed description of the Leeds textile trade:

Leeds is a large, wealthy and populous town, it stands on the north bank of the River Aire, or rather on both sides the river, for there is a large suburb or part of the town on the south side of the river, and the whole is joined by a stately and prodigiously strong stone bridge, so large, and so wide, that formerly the cloth market was kept in neither part of the town, but on the very bridge itself; and therefore the refreshment given the clothiers by the inn-keepers, of which I shall speak presently is called the Brigg-shot to this day.

The encrease of the manufacturers and of the trade, soon made the market too great to be confined to the brigg or bridge, and it is now kept in the High-street, beginning from the bridge, and running up north almost to the market-house, where the ordinary market for provisions begins, which also is the greatest of its kind inall the north of England, except Hallifax ... The street is a large, broad, fair, and well-built street, beginning, as I have said, at the bridge, and ascending gently to the north...

There are for this purpose [the selling of cloth] a set of travelling merchants in Leeds, who go all over England with droves of pack horses, and to all the fairs and market towns over the whole island ... they supply the shops by wholesale or whole pieces; and not only so, but give large credit too ... tis ordinary for one of these men to carry a thousand pounds value of cloth with them at a time.

Warehouse-keepers not only supply all the shop-keepers and wholesale men in London, but sell also very great quantities to the merchants, as well for exportation to the English colonies ... especially New England, New York, Virginia, and as also to the Russia merchants, who send an exceeding quantity to Petersburgh, Riga, Dantzic, Narva, and to Sweden and Pomerania ... the merchants,

that is to say, such as receive commissions from abroad to buy cloth for the merchants chiefly in Hamburgh, and in Holland, and from several other parts; and these are not only many in number, but some of them are very considerable in their dealings, and correspond as far as Nuremberg, Frankfort, Leipsick, and even to Vienna and Ausburgh, in the farthest provinces of Germany.

Around the same time, Ralph Thoresby (1658–1725), the north's answer to Samuel Pepys, kept a diary and published his famous *Ducatus Leodiensis* (1715), aka the *First History of Leeds*. The city's historical society, which was formed in 1889, was named after him.

By the eighteenth century Leeds was largely a mercantile town. In the 1770s, Leeds merchants contributed 30 per cent of the country's woollen exports, valued at £1.5 million; seventy years previously Yorkshire accounted for only 20 per cent of the nation's exports. There were, of course, other industries. Leeds Pottery was founded in 1770, there were brickmakers, coach makers, clockmakers, booksellers and jewellers, and the first newspaper in Leeds went to press in 1718. Over the years trade included flax, cotton, silk, engineering, locomotives, carpets, off-the-peg clothing at Burton's, brewing at Tetleys from 1822, confectionery at Quaker Henry Thorne at Kirkstall, military shell filling at Barnbow and tanks at Vickers.

The population exploded from 10,000 in the late seventeenth century to 30,000 in the late eighteenth. By the standards of the time it was a large town. The Industrial Revolution fuelled population growth. Leeds's industrial resurgence had been galvanised by the opening of the Aire & Calder Navigation in 1699, the Leeds and Liverpool Canal in 1816 and the railways from 1834. By 1841 the population of Leeds

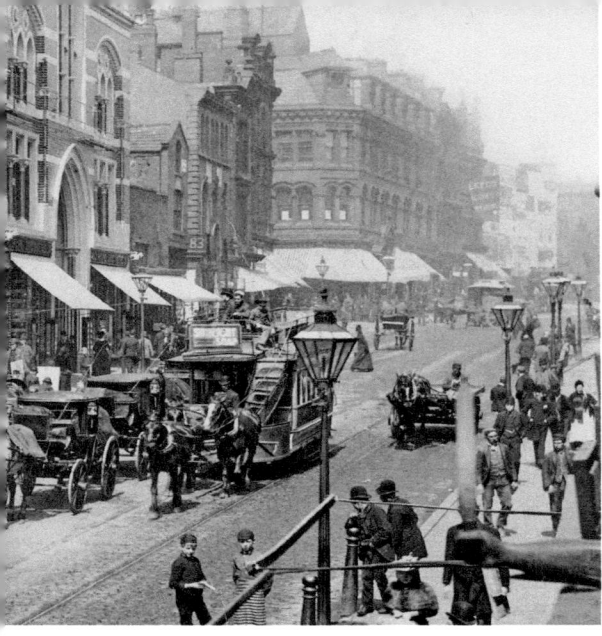

was 88,000. At the end of the century the *Yorkshire Factory Times* described Leeds as 'a miniature London', and on 11 September 1858 *The Illustrated London News* reported that Leeds was the 'largest and most flourishing city in Yorkshire'. The population in 1851 reached 172,270 and the number of inhabited houses was 36,165.

As in other cities, Leeds faced a critical housing problem, with many of its squalid back-to-back houses condemned as unfit for human habitation. During the interwar years sprawling council estates and private housing were built. The most interesting – and disastrous – of these schemes was Quarry Hill Flats, built between 1935 and 1941, providing homes for over 3,000 people. During the Second World War seventy-seven Leeds people were killed and 197 buildings were destroyed.

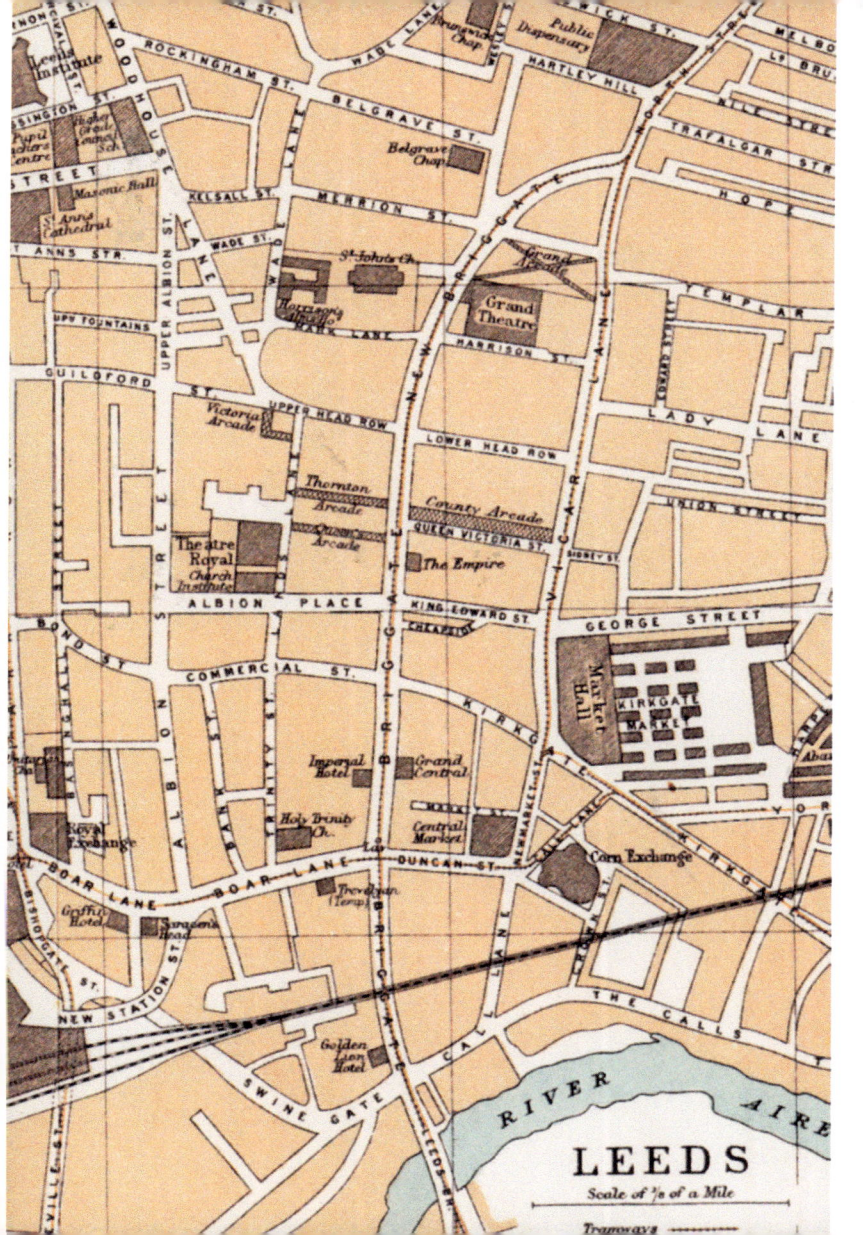

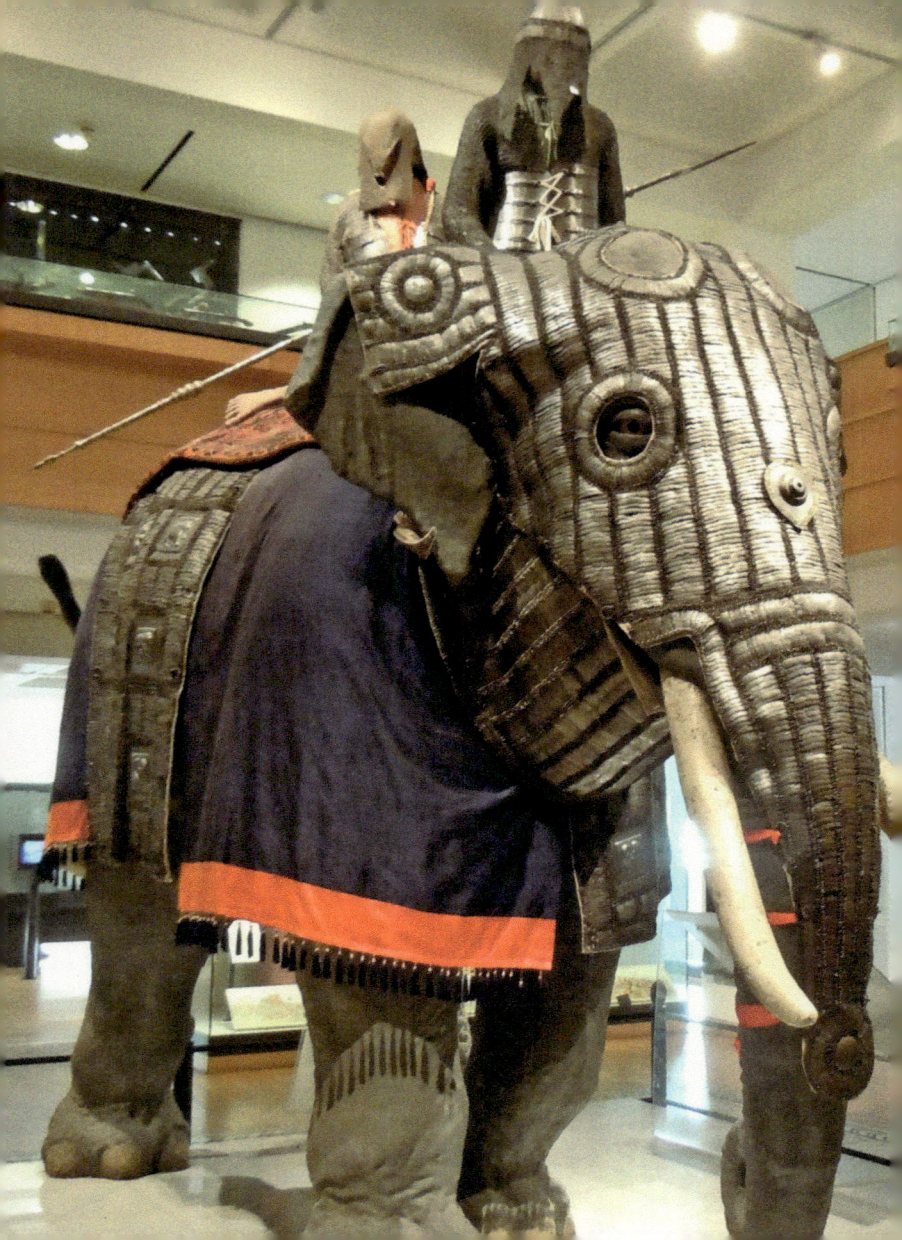

1. ROYAL ARMOURIES MUSEUM (1996), ARMOURIES DRIVE, CLARENCE DOCK

An armoured elephant, an early version of the tank and one of the first weapons of mass destruction.

The Royal Armouries Museum displays the National Collection of Arms and Armour and is the National Firearms Centre. It is part of the Royal Armouries family of three museums, the others being the Tower of London and Fort Nelson, near Portsmouth. Five galleries house 75,000 objects, along with the Peace Gallery. The museum also features the Hall of Steel, a huge staircase 'whose walls are decorated with trophy displays composed of 2,500 objects reminiscent of the historical trophy displays erected by the Tower Armouries from the seventeenth century'.

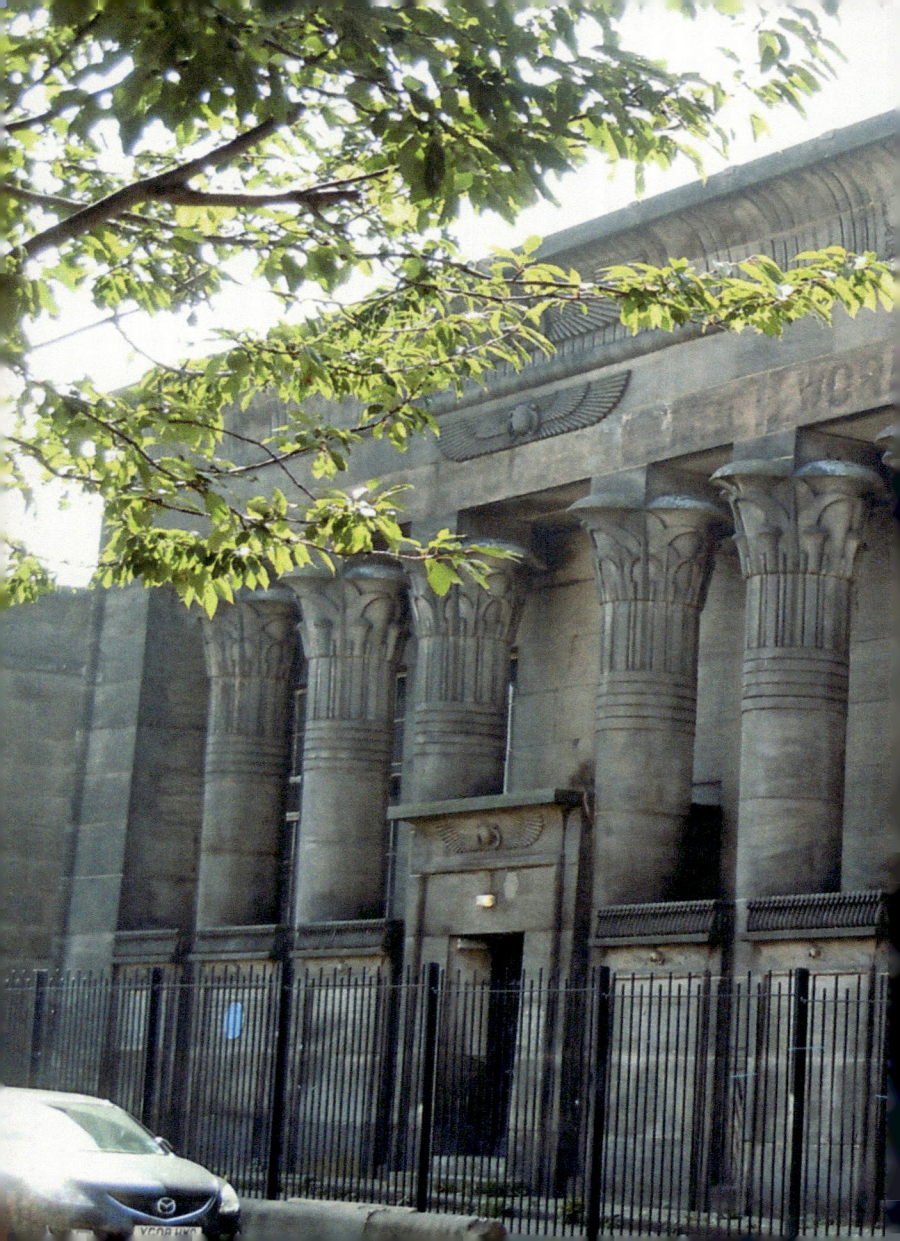

2. TEMPLE WORKS

Exoticism is plentiful at Temple Works, a former flax mill by Joseph Bonomi and based on the temple at Antaeopolis and the Temple of Horus at Edfu, with a chimney in the shape of an obelisk. The factory building was modelled on the Typhonium at Dendera. To this day it is referred to in schools of architecture and engineering the world over, not just for the truly awesome façade but also for the unique and visionary engineering solution used for the main mill floor, which is reminiscent of Frank Lloyd Wright's Johnson Wax Building completed 100 years later in Racine, Wisconsin. Apart from this wonderful façade, Bonomi was also responsible for *Nineveh and its Palaces* and other works on Egypt, Nubia and Ethiopia, illustrated with his own drawings. In addition, he designed a house (The Camels) at Wimbledon, and he is known for inventing a machine that measures the proportions of the human body.

Sheep grazed on the roof here, not just as a gimmick but to retain humidity in the flax mill to prevent the linen thread from becoming dried out and unworkable. Sheep, of course, are not very good at climbing ladders or stairs, so the hydraulic lift was invented in order to get them onto the roof and down again.

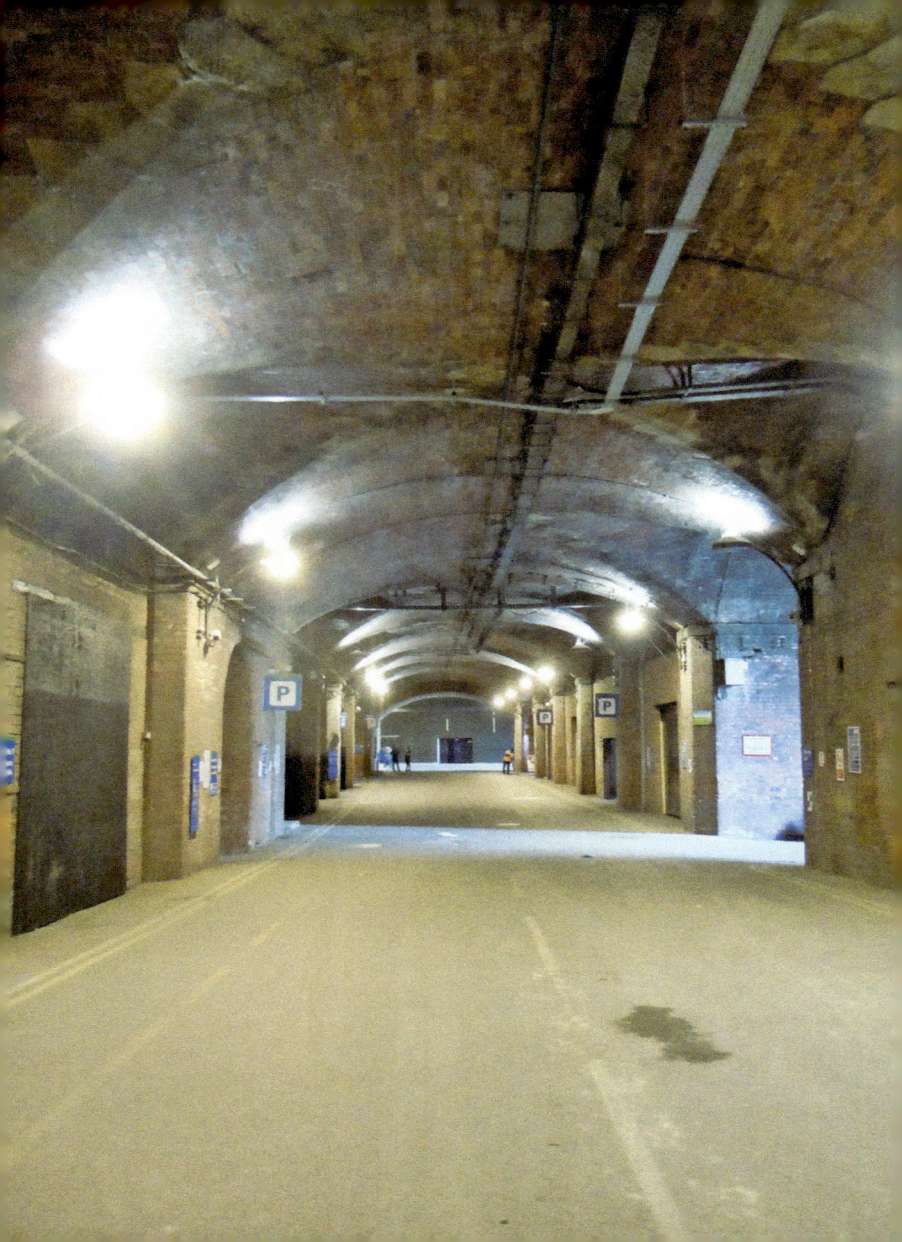

3. THE CANAL AND THE DARK ARCHES

Arches to let in industrial Leeds. Leeds station was built over a series of arches, spanning the Aire, Neville Street and Swinegate, and the Dark Arches can still be seen today. More than 18 million bricks were used in their construction, a record at the time in what was a series of independent viaducts two or four tracks wide. The station is at the terminus of the Leeds and Liverpool Canal, but as it is raised high above ground level you can access the Dark Arches from the towpath.

At first, the arches were used for storage – some of them by soap manufacturers Joseph Watson & Sons to store resin, oil and tallow. Unfortunately, in 1892 these inventories, the bridge and the railway line over the canal basin were destroyed in a fire. The bridge was rebuilt and the line restored in just five and a half days. Joseph Watson & Sons' Whitehall Soap Works was one of the largest soap works in England, employing around 750 people and manufacturing 600 tons of soap a week in 1893.

The Dark Arches is now part of Granary Wharf, with shops, restaurants, markets and street entertainers.

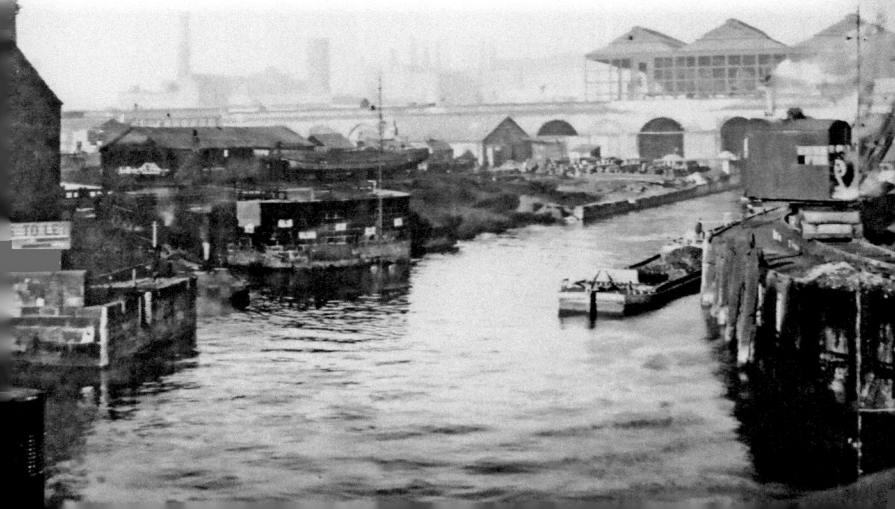

4. TIME BALL BUILDINGS, BRIGGATE

A precious and rare surviving example of elaborate and ornate Victorian-Edwardian shop innovation and design. The premises has had a number of occupants over the years: distiller, saddler and trunk maker, a barber and perfumer and a stationer through the nineteenth century. Then in 1872 J. Dyson, watchmaker, who was at Nos 26/27, occupied the whole building. Most of the elaborate façade was added by Dyson. Bay windows flank the large pedimented clock case at Nos 25 and 26. At No. 24, Father Time surmounts a large, framed clock on the third storey. There are ironwork spandrels, the letters 'D. & S.' and the words 'Tempus Fugit'. Gold lettering shows the date as 1865. The stunning gilded time ball mechanism was linked to Greenwich and dropped at precisely 1 p.m. each day. This feature, together with the window mechanism, which raised and lowered the window displays, allowing safe storage in the vaults each night, makes Dyson's unique.

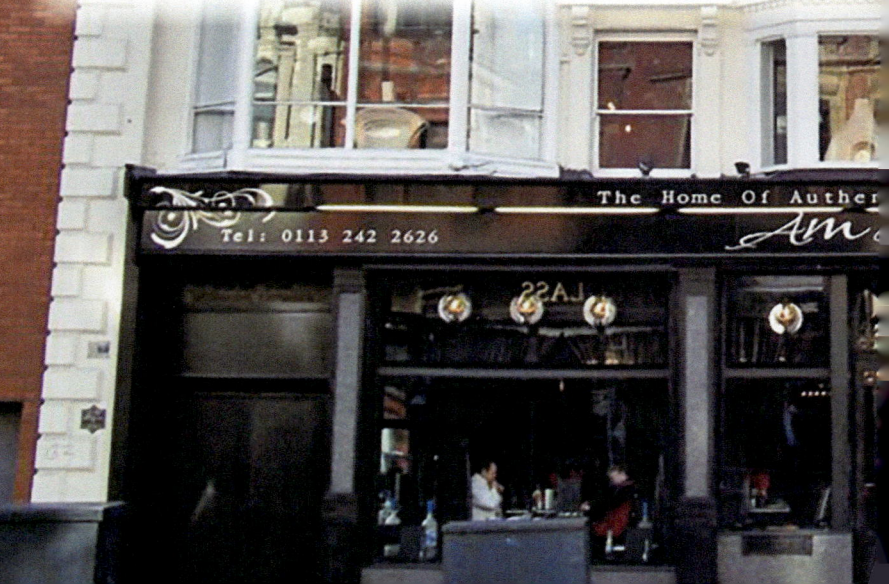

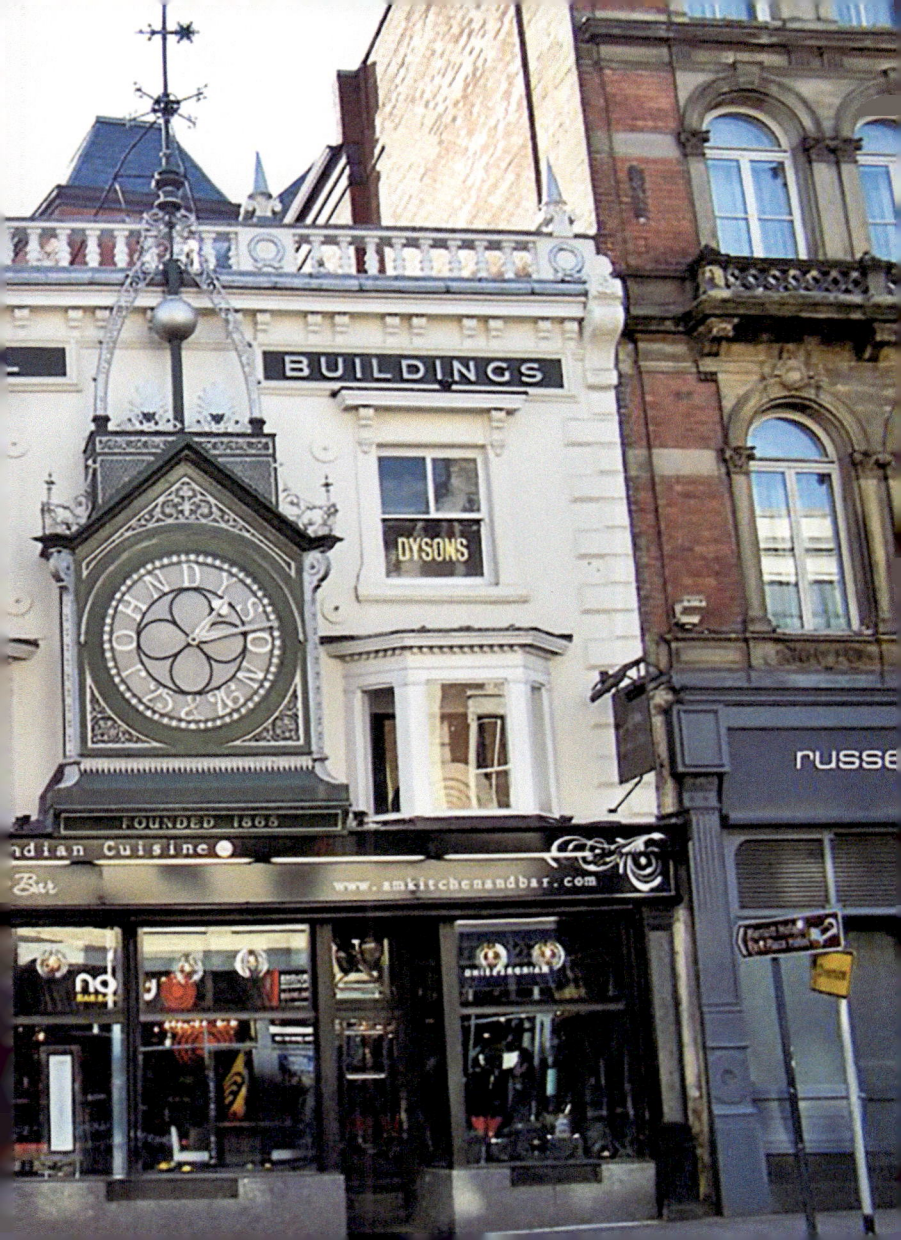

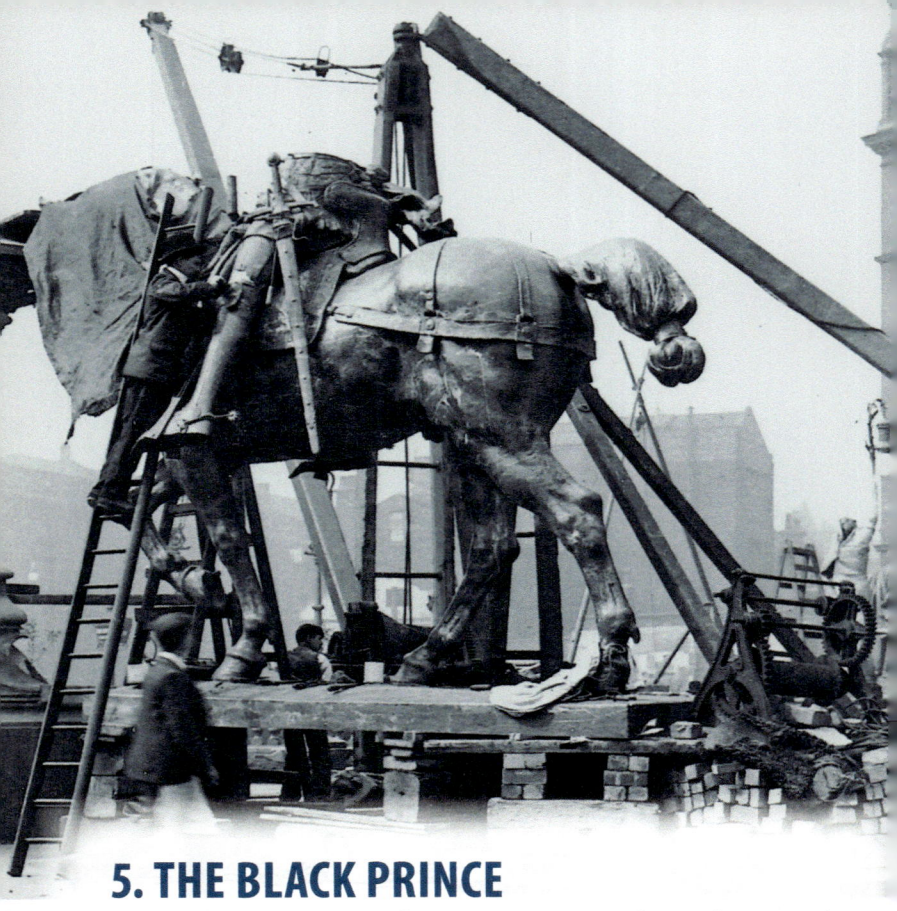

5. THE BLACK PRINCE

The Black Prince statue took seven years to complete and was cast in Belgium because it was too big for any British foundry. It was brought to City Square by barge from Hull along the Aire & Calder Navigation and unveiled on 16 September 1903.

Some other grand statues embellish the city, including local heroes Joseph Priestley, founding father of modern chemistry;

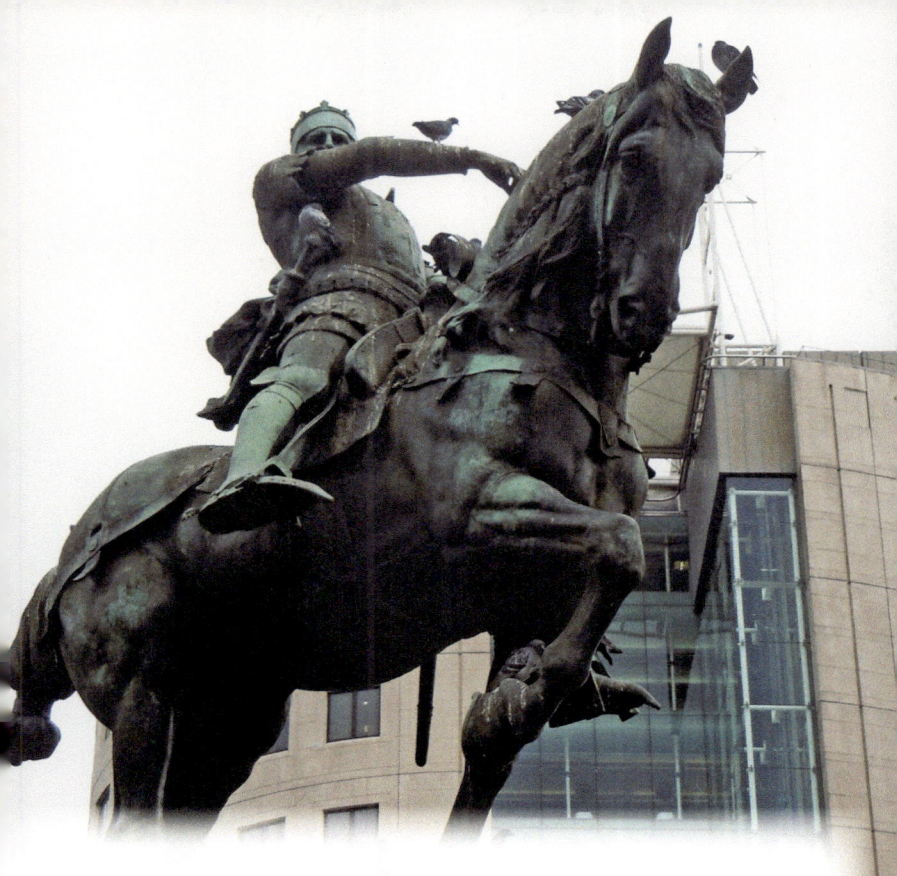

John Harrison, early woollen cloth merchant and Leeds benefactor; and James Watt of steam engine fame. The Black Prince (son of Edward III) has nothing to do with Leeds. The statue was a gift from Colonel Thomas Walter Harding, Lord Mayor of Leeds between 1898 and 1899, and was just someone Harding admired, symbolising, as he did, democracy and chivalry. (Courtesy of Leodis, Leeds Library & Information Services)

6. THE WHITE CLOTH HALL (1711), KIRKGATE

Leeds, lying on the fringes of the Yorkshire cloth-producing district, had to compete for trade with better-placed neighbouring towns. As such, in 1711 all the cloth business was centralised in the purpose-built White Cloth Hall on Kirkgate from Briggate. Indeed, Leeds' White Cloth Hall was a direct riposte to the merchants of Wakefield, who, in an undisguised attempt to attract business away from Leeds, built a cloth hall to house their market. This was much better than the Leeds market at the time, since it was indoors and protected from the weather. Leeds merchants had no choice but to do the same, and a cloth hall for the trading of white (undyed) cloth was built on Kirkgate.

Predictably, perhaps, the Leeds trade soon outgrew the cloth hall, and in 1755 the clothiers financed the building of the second White Cloth Hall south of the river on Meadow Lane. This second White Cloth Hall also soon proved inadequate and, smarting at the opening of a rival cloth hall at Gomersal, in 1774 the Leeds merchants agreed on the building of a third hall in Leeds. A site was found on a piece of land called the Tenter Ground in The Calls.

7. THE CORN EXCHANGE, CALL LANE

Corn has been formally traded in Leeds since the seventeenth century when the corn market was at the top of Briggate, between the Market Cross and New Street (now New Briggate). Growing trade led, in 1827, to the building of a corn exchange at the top of Briggate, but by the mid-nineteenth century this also proved too small. So, in 1860, a new corn exchange was proposed. It featured a large central space surrounded by fifty-six offices, accessed by arched doorways – some of them opened onto the street, while others opened into the interior of the building. Corn was stored in the huge basement area. It was also used as the headquarters of the fire brigade for a while. The photos show the Corn Exchange in 1930 and 2014.

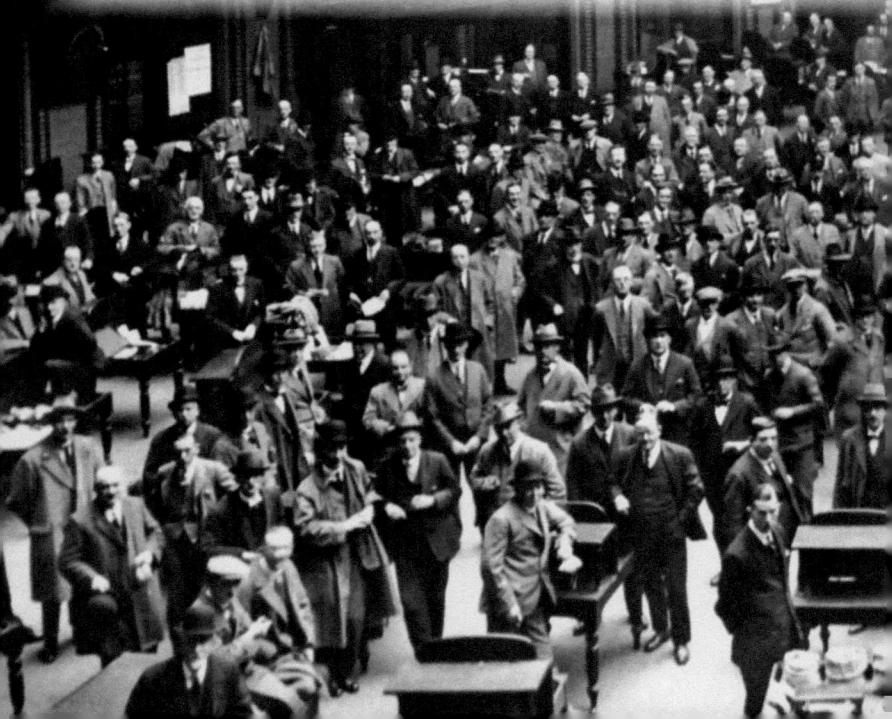

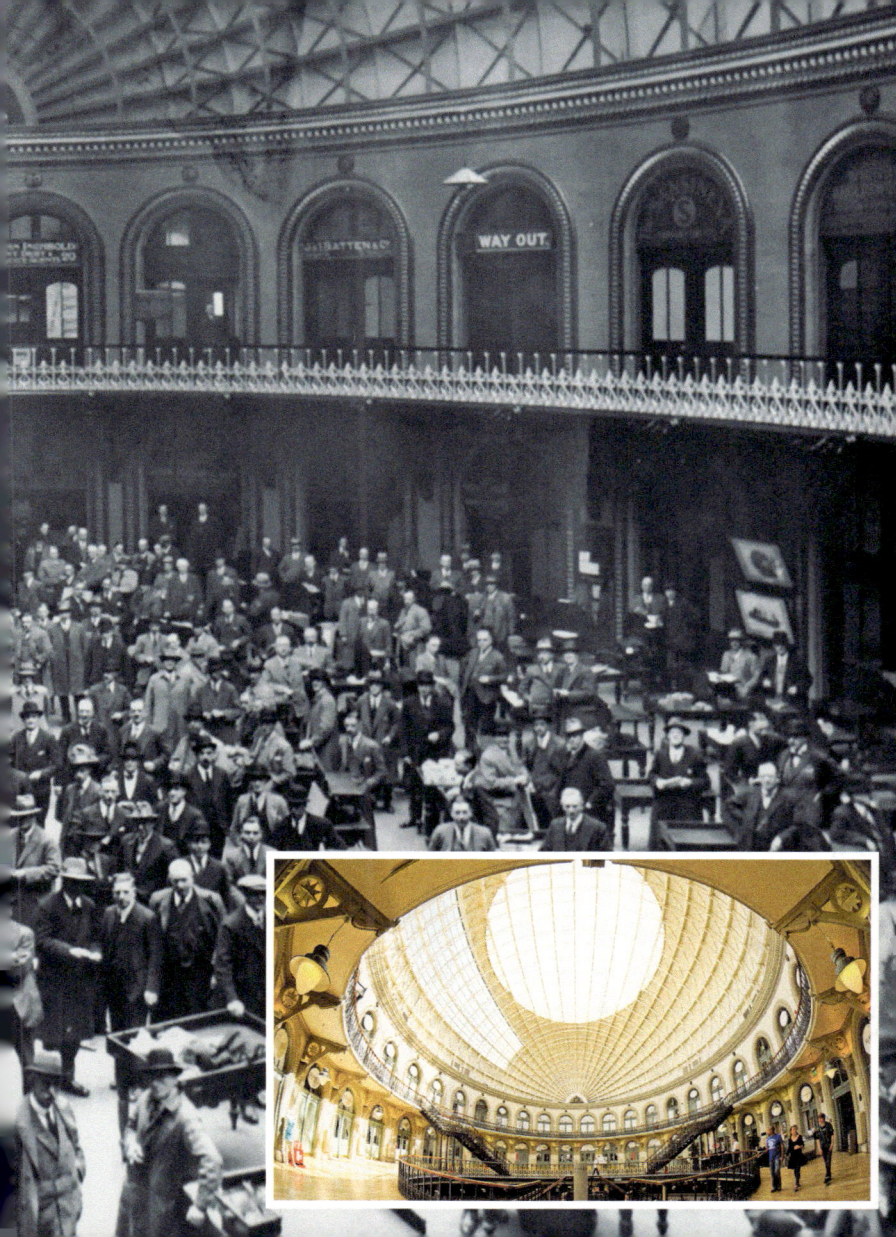

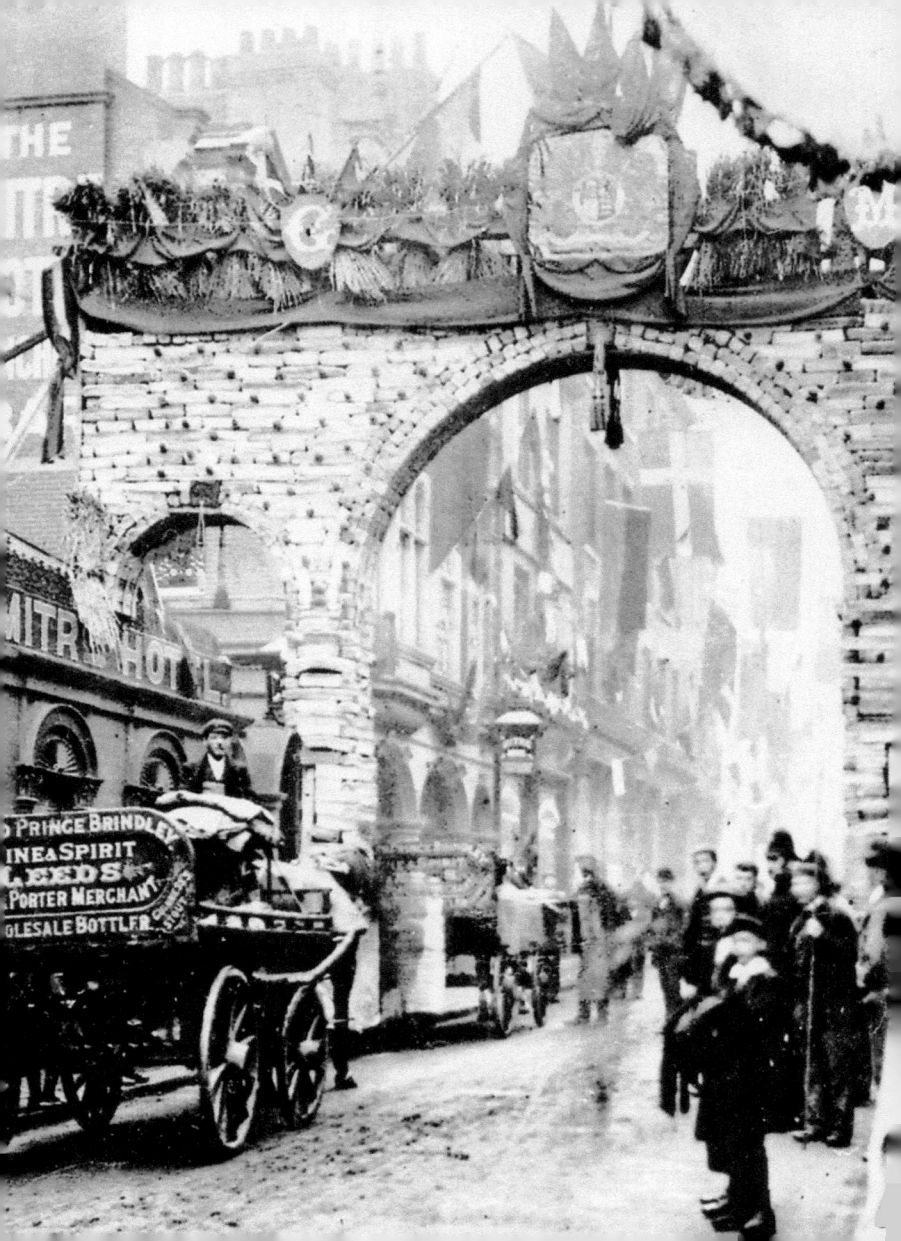

8. THE BREAD ARCH, COMMERCIAL STREET

On 5 October 1894, the citizens of Leeds built an archway made of bread to mark the visit by the Duke and Duchess of York (the future George V and Queen Mary), who were there to open the Medical School and College Hall of Yorkshire College (now Leeds University). The novel structure spanned the width of Commercial Street, near Briggate, and weighed 5 tons. It was made of white, brown and spiced loaves. It was the creation of Henry Child, who ran the Mitre Hotel, to which the arch was attached. William Morris, who ran a bakery in Pack Horse Yard, baked the bread, which was the equivalent of hundreds of loaves, the flour for which cost £20 and was paid for by Henry Child. The plan was to distribute the loaves to the poor after the visit, but rain scuppered the event.

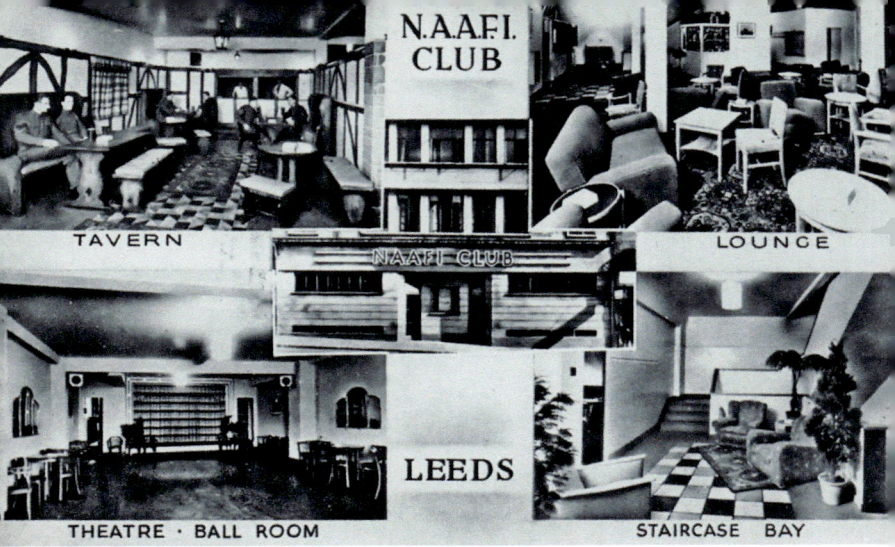

9. THE NAAFI CLUB AND LEEDS LIBRARY

Four pictures promoting the Leeds Navy, Army and Air Force Institutes Club on the corner of Albion Street and Albion Square, which later became the YMCA. Since 1808, Commercial Street has been the home of the Leeds Library, pictured opposite in 2016 in all its Greek Revival splendour. Leeds Library, founded in 1768, is the oldest surviving subscription library in the UK; the first secretary was Joseph Priestley. The library has over 800 members who pay an annual subscription and has a stock of over 140,000 titles.

THE LEEDS LIBRARY

LEEDS LIBRARY

10. CHICKENS IN BOAR LANE

R. Boston & Sons in Boar Lane were one of Leeds's top-end game, fruit and fish stores. Waddington's 1894 *Guide to Leeds* tells us that Boston's provided fifty types of fish, including oysters, every imaginable kind of bird, thirty-six different types of vegetable and 100 fruits. Richard Boston (1843–1908) was a major Leeds benefactor.

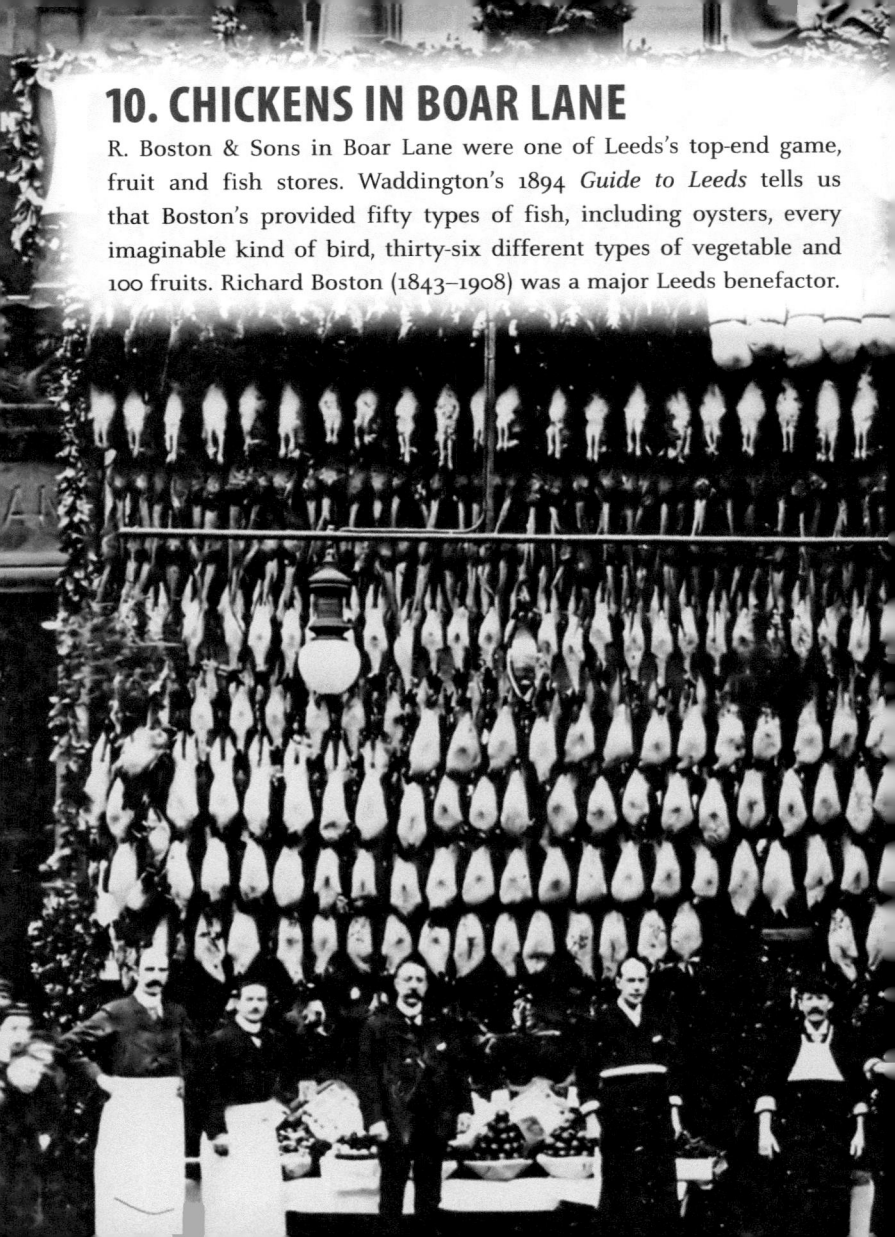

N & SONS

11. THE GRIFFIN, BOAR LANE

This pub is on the site of the earlier Griffin Hotel, a coaching inn from at least the seventeenth century. The building was restructured as a railway hotel for the new station, which opened in 1869, and was owned by the joint London & North Western and North Eastern railways. The Gothic Revival structure boasted a unique Potts clock at the corner of the building, with the hours ingeniously replaced by the words 'Griffin Hotel'. For many, though, the Griffin will be cherished as the place where Leeds United was born.

12. WHITELOCK'S ALE HOUSE, TURK'S HEAD YARD, OFF BRIGGATE

Grade II listed Whitelock's Ale House first opened its doors in 1715 as the Turk's Head Inn, fittingly enough on Turk's Head Yard. It is Leeds's oldest surviving pub. In 1867, John Lupton Whitelock, a flautist with the Hallé and Leeds Symphony Orchestra, was granted the licence of the Turk's Head. The Whitelock family bought the pub and in 1886 completed a refurbishment, which is the décor we can see today, including the long marble bar, etched mirrors and glass. In the mid-1890s, the pub was rebadged as Whitelock's First City Luncheon Bar and in 1897 John Lupton Whitelock installed electricity, including an exciting new revolving searchlight at the Briggate entrance to the yard. Trick beer glasses, in which a sovereign was placed, ensured the punter got not the money but an electric shock. John Betjeman described Whitelocks as 'the Leeds equivalent of Fleet Street's Old Cheshire Cheese' and 'the very heart of Leeds'. One of the great bars of the world, the pub rubs shoulders with the Long Bar in Shanghai's Peace Hotel and Harry's in Venice.

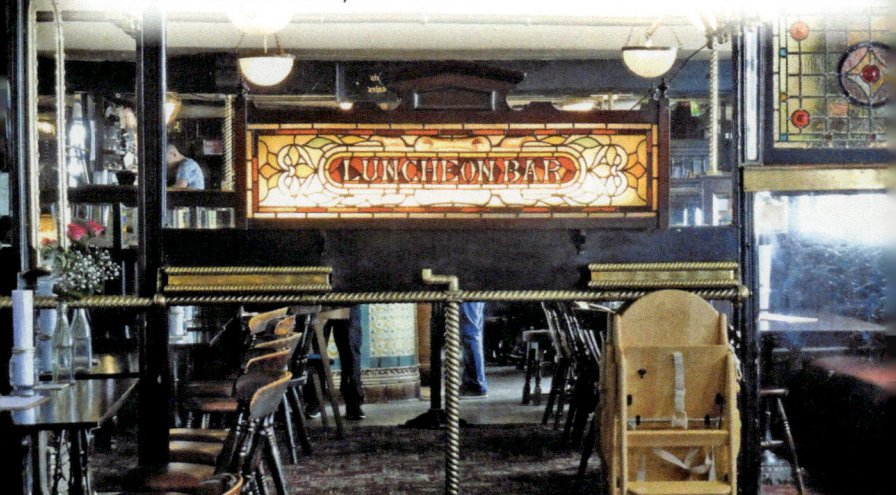

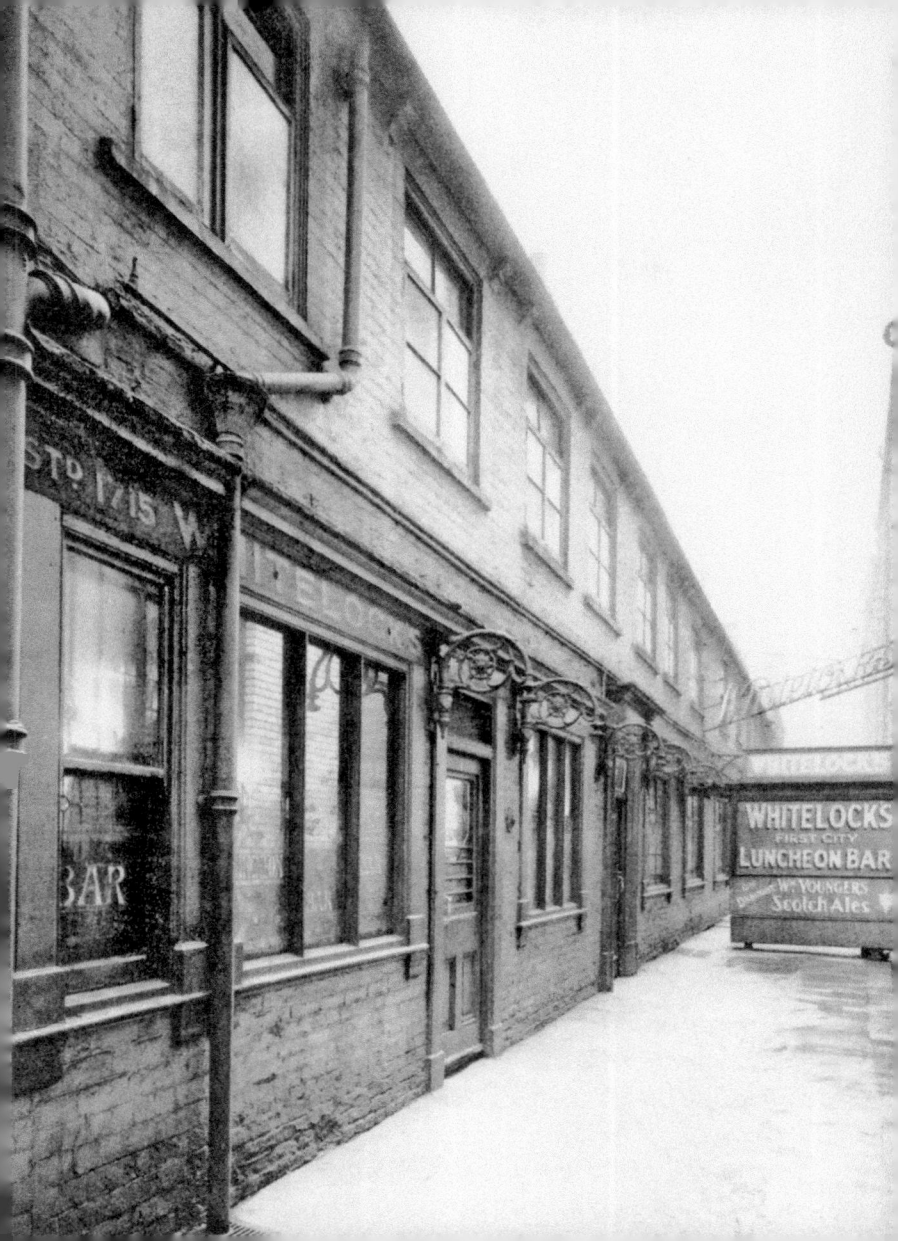

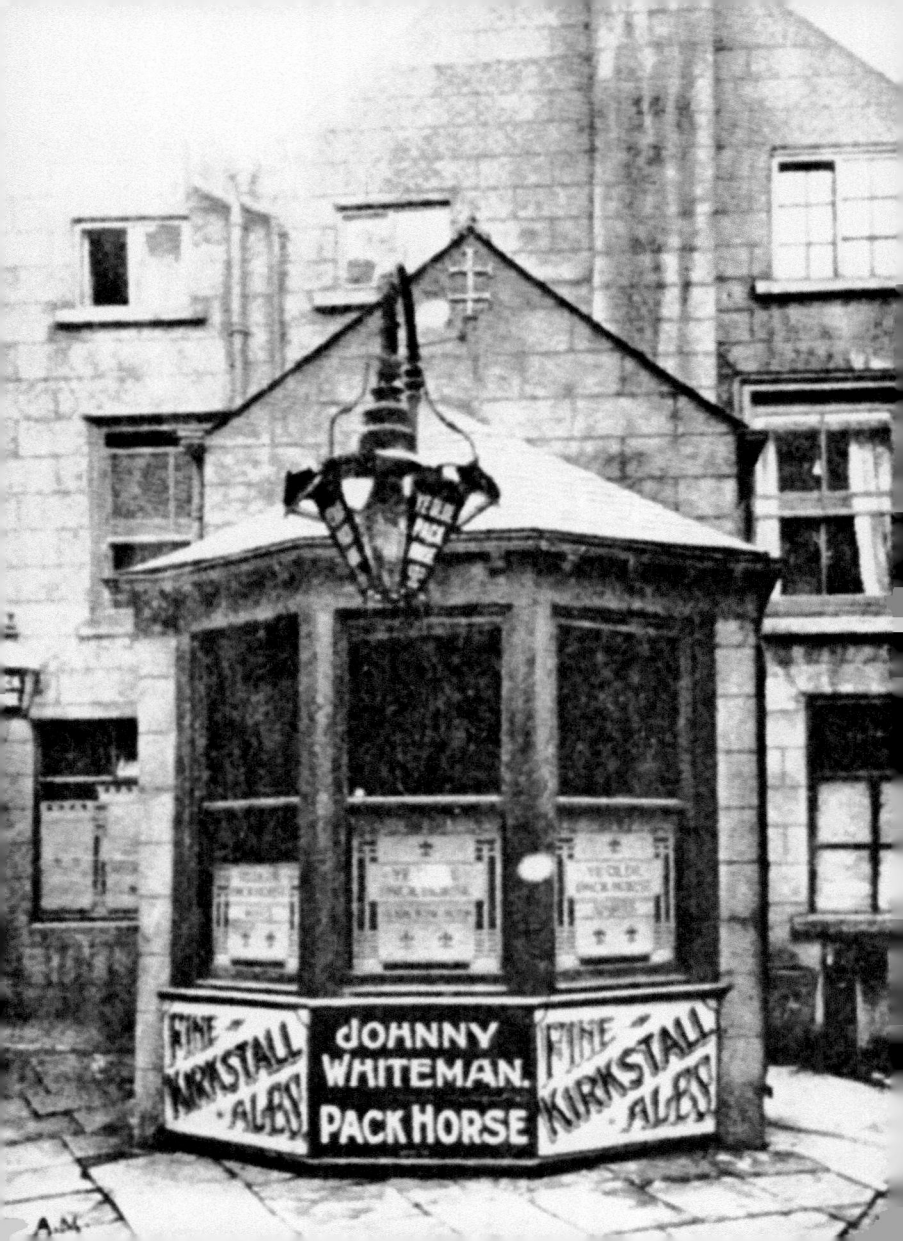

13. THE PACK HORSE, OFF BRIGGATE

The Templar cross can be seen at the front of this ancient pub in Pack Horse Yard, off Briggate. The cross tells us that it was originally part of the manor of Whitkirk and it was owned by the Order of St John of Jerusalem, successors to the Knights Templar. It opened in 1615, although there may have been a drinking house on the site in the sixteenth century. Some say it goes back to the 1130s. In 1615, it was the Nag's Head and then the Slip Inn from 1770. It was renovated in 1982 when fifteenth-century elements were discovered. The Harrison Arms in Harrison Street and the Old George Commercial Hotel also bear a Templar cross.

14. CITY VARIETIES MUSIC HALL, SWAN STREET, OFF BRIGGATE

In 1760, City Varieties was born when the White Swan coaching inn was built in a yard off Briggate, on the White Swan Yard. The White Swan featured a singing room upstairs, where various acts were staged. Charles Thornton became the licensee of the White Swan in 1857 and reopened the new, refurbished 2,000-seat venue in 1865 as Thornton's New Music Hall and Fashionable Lounge. It remains a rare surviving example of Victorian-era music halls of the 1850s and 1860s. In 1898, the theatre was sold to Fred Wood, who booked acts such as Charlie Chaplin, Lily Langtry and Laurel and Hardy. When Lily Langtry performed there Edward VII would visit her and, in gratitude for the theatre's discretion, he donated the crest that is now displayed above the auditorium.

Between 1913 and 1915 the theatre held wrestling matches for local men. The Christmas pantomime of 1941, *Babes in the Wood*, featured unique audience participation when a woman in the audience unexpectedly gave birth to a 'healthy ginger-haired boy'. Harry Joseph, the owner, gave the child free admission for life. Even less conventional performances included the lady who hypnotised an alligator to music and, in the 1950s, striptease shows were put on, in which the girls were allowed to pose but not to move.

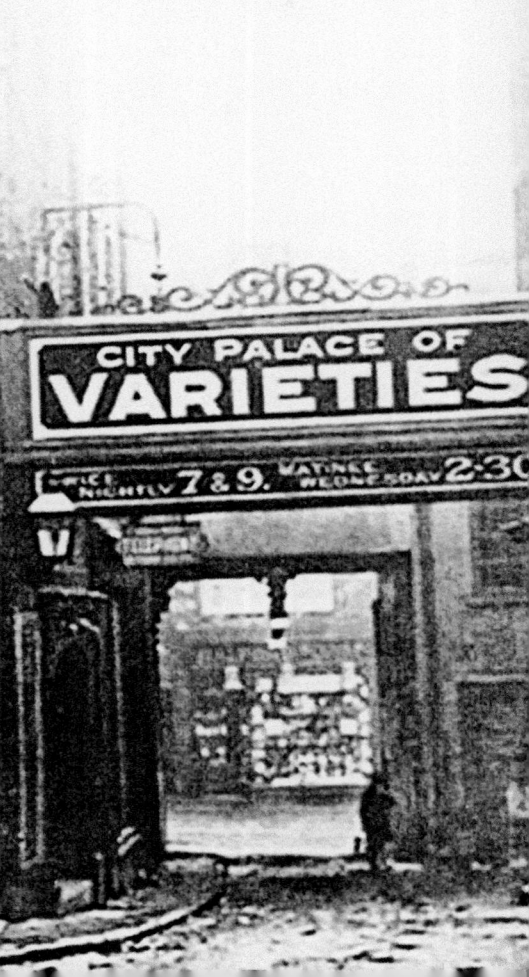

15. COUNTY ARCADE, 1907

At the western end of County Arcade was The Bazaar, a two-storey emporium – the lower level selling meat and the upper level selling fancy goods and haberdashery. Men and women were segregated: men downstairs, women upstairs, with no chatting, no drinking or eating behind the counters, and none of that wearing of bonnets by the women. These ornate arcades were designed by Frank Matcham and were two storeys high with shops confined to the ground level. There are pink marble columns between the mahogany shopfronts, and there is elaborate Burmantofts faience work above the cast-iron balustrades. The vaulted ceiling is glass with three domes displaying mosaic figures representing Liberty, Commerce, Labour and Art.

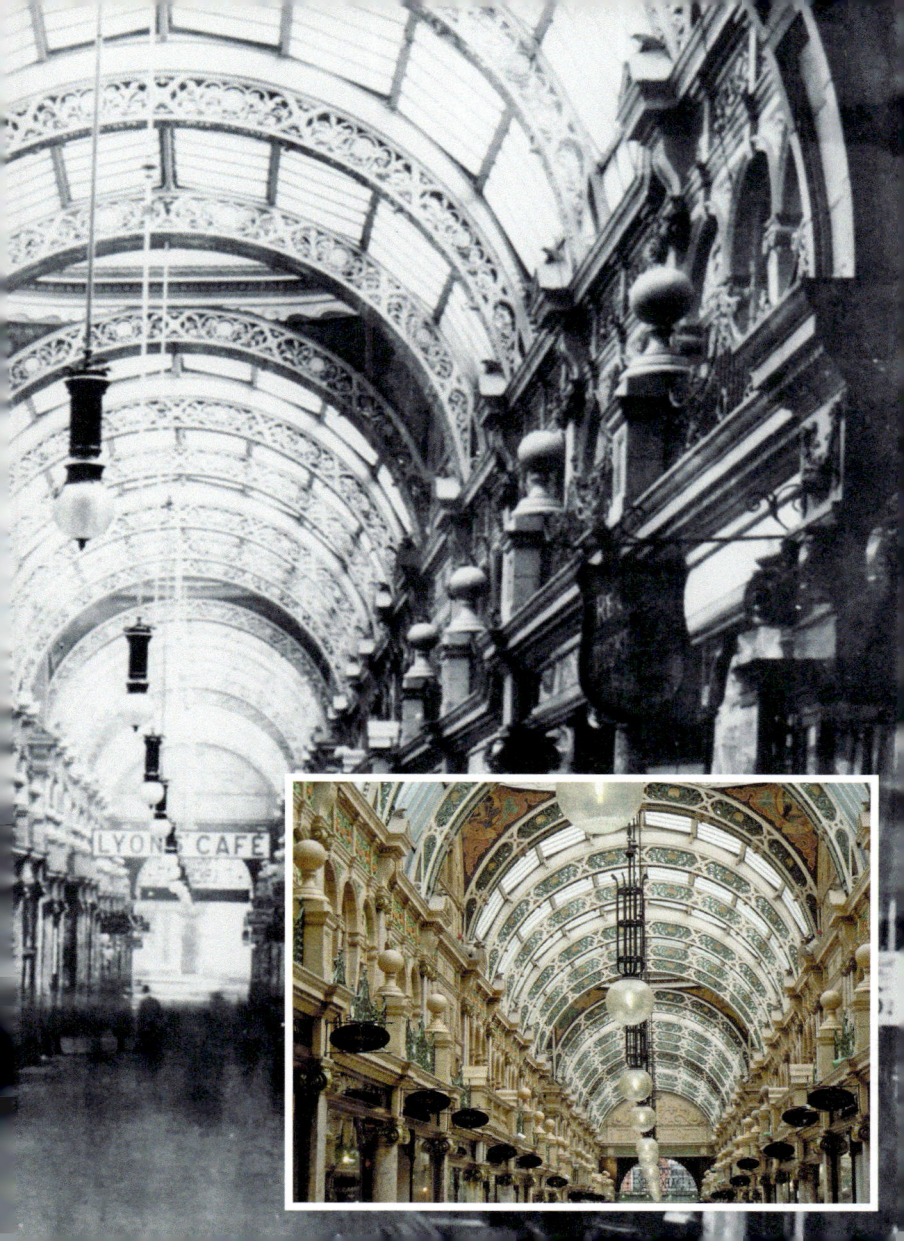

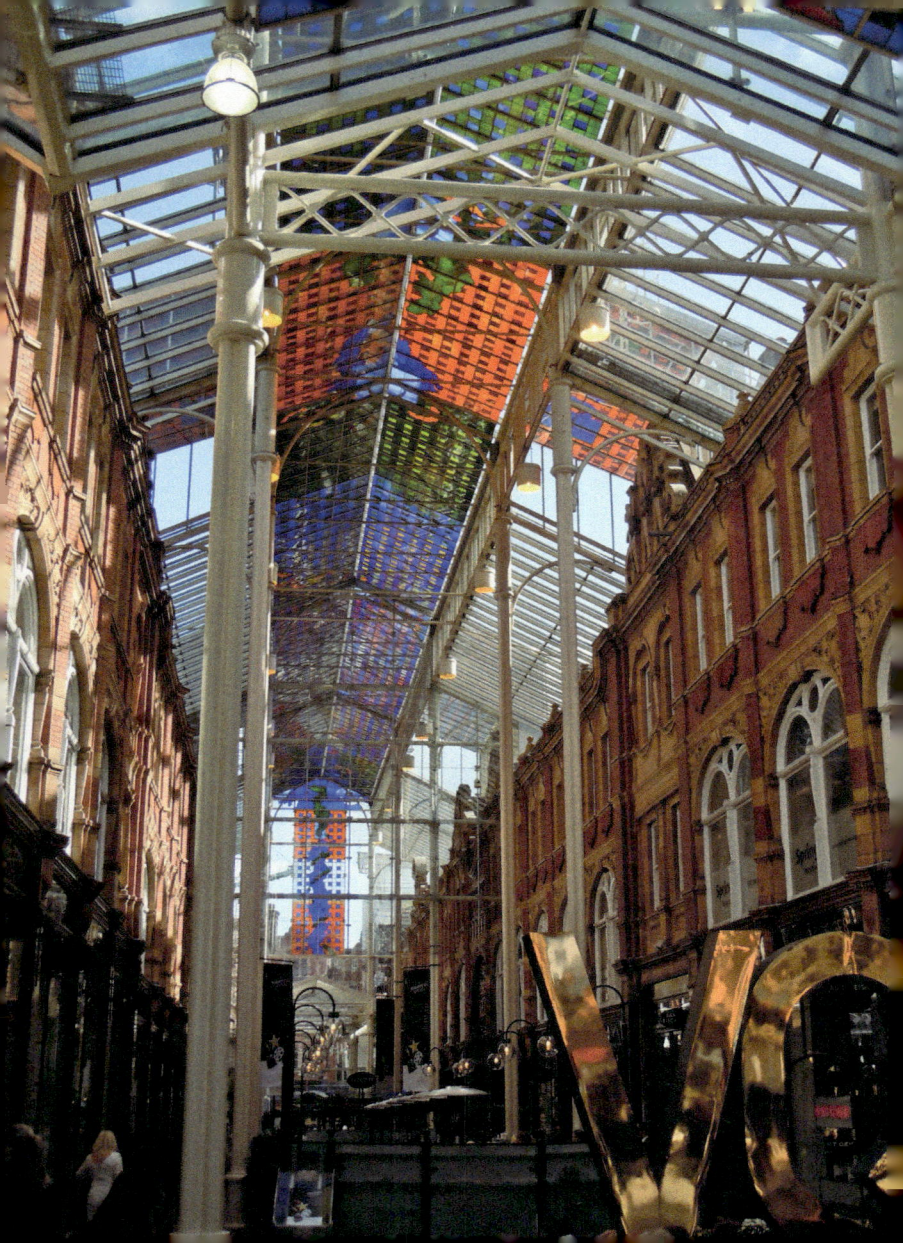

16. THORNTON'S ARCADE (1878), VICTORIA QUARTER, OFF BRIGGATE

The buildings and conditions in what was to become the beautiful Victoria Quarter could not have been more different before 1877. Vicar Lane was full of slaughterhouses, butchers and fruit and vegetable stalls. That was before the famous theatre architect Frank Matcham was commissioned to redevelop the area. The arcade is famous for its clock, made by William Potts & Sons of Leeds, which features animated life-sized characters from Sir Walter Scott's *Ivanhoe*. Robin Hood and Gurth the Swineherd strike the quarter hours, and Friar Tuck and Richard the Lionheart strike the hours. At the other end of the arcade is a woman's head sporting long, curling hair and a large hat. It is modelled on Gainsborough's portrait of the Duchess of Devonshire. Its coloured roof, stretching the 400 feet from one end of the street to the other, is still the largest single work of stained glass in Great Britain.

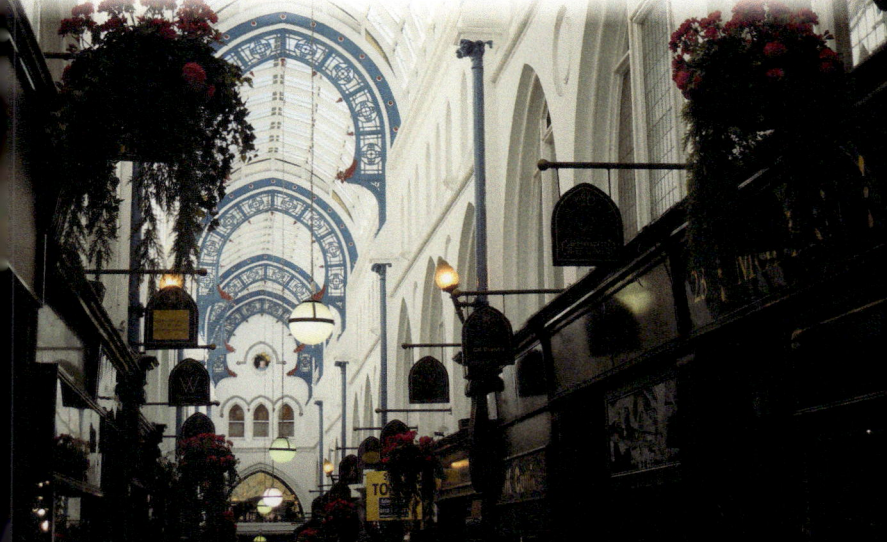

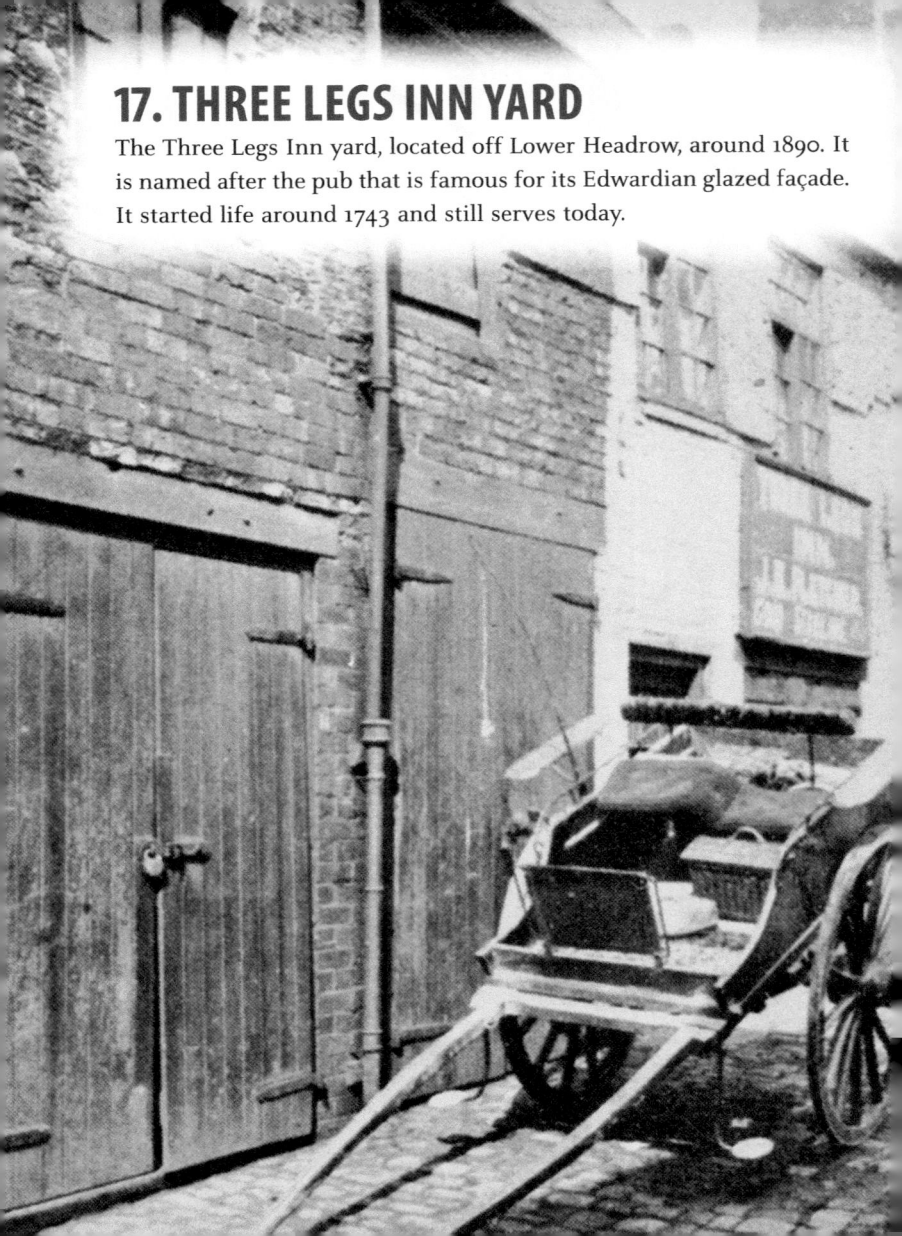

17. THREE LEGS INN YARD

The Three Legs Inn yard, located off Lower Headrow, around 1890. It is named after the pub that is famous for its Edwardian glazed façade. It started life around 1743 and still serves today.

18. LEEDS TOWN HALL (1858), THE HEADROW

The Town Hall (seen here in 1912) is a symbol of the grandeur that was Victorian Leeds. Built on Park Lane (now the Headrow), it was an expression of civic pride and a reflection of the wealth brought to the city by the textile industries. At 225 feet it was Leeds's tallest building from 1858 until 1966, when it lost out to the Park Plaza Hotel, which was 26 feet taller. It held this title longer than any other building in the city – 108 years.

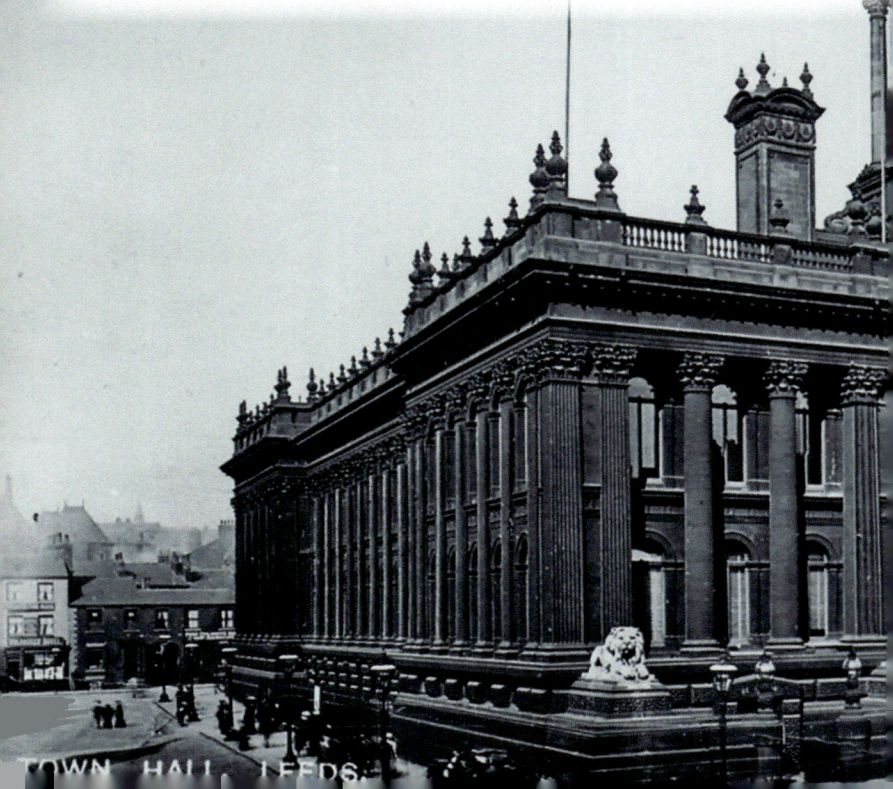

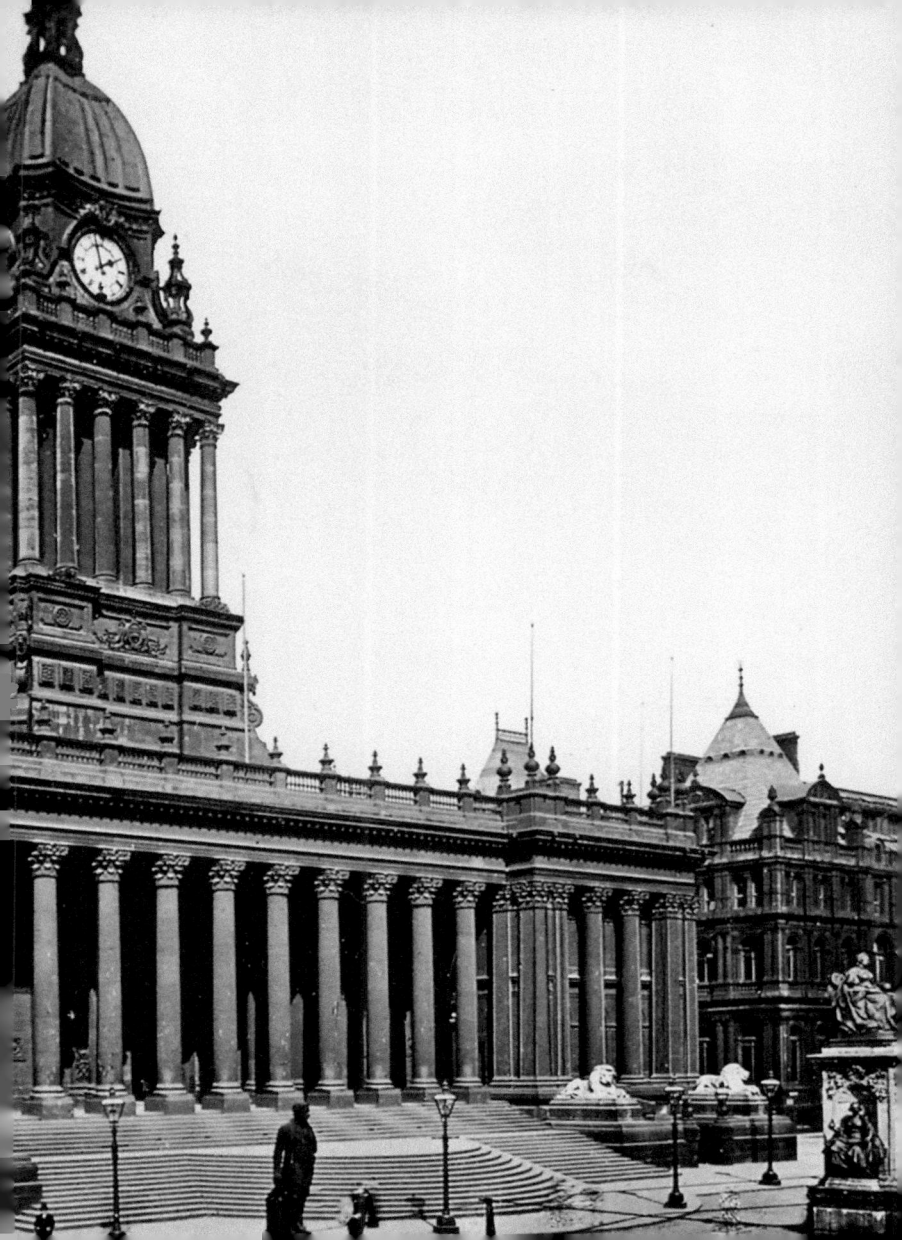

19. HOPING ON THE TOWN HALL STEPS: THE SECOND BRITISH ESPERANTO CONGRESS, 1909

On the steps of the Town Hall. Esperanto (meaning 'one who hopes') is the most widely spoken artificial language in the world. Its name comes from Doktoro Esperanto, the pseudonym under which physician and linguist L. L. Zamenhof published the first book about Esperanto, *Unua Libro*, in 1887. Zamenhof's aim was 'to create an easy-to-learn, politically neutral language that would transcend nationality and foster peace and international understanding between people with different languages'. Up to 2 million people worldwide routinely speak Esperanto, including 1,000 native speakers who learned the language from birth.

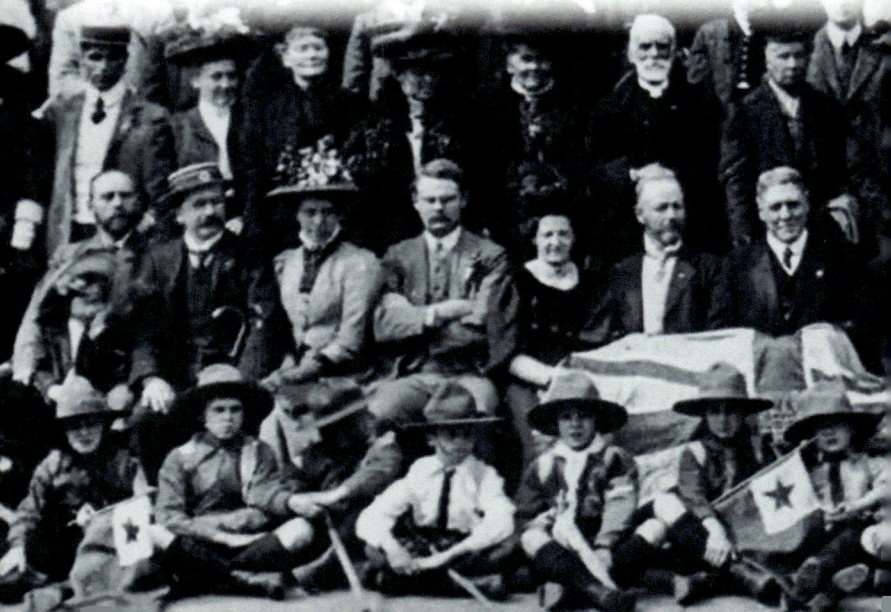

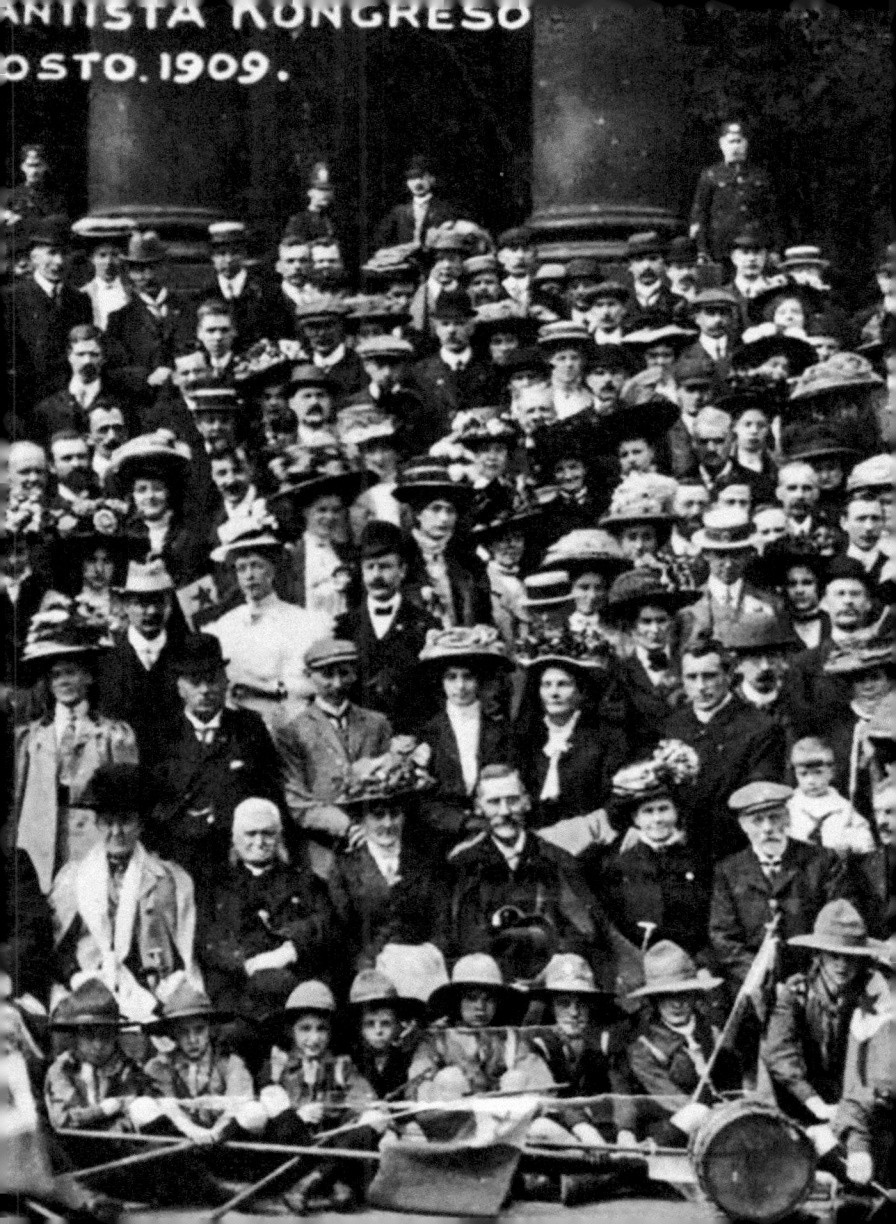

20. LEEDS ART GALLERY (1888), THE HEADROW

The gallery opened on 3 October 1888 as Leeds City Art Gallery. Leeds Art Gallery, as it is now called, has been described as 'probably the best collection of twentieth century British art outside London' (John Russell Taylor, *The Times*). The magnificent Tile Hall was originally the Sculpture Room and is now a café. Before it housed the sculpture it was the Reading Room from 1888 and housed the Commercial and Technical Library from 1955.

The twentieth-century exhibits are officially regarded as a collection 'of national importance'. To prove that, it includes works by local artists such as Henry Moore, Barbara Hepworth, Atkinson Grimshaw, Jacob Kramer, as well as from a range of contemporary artists including Bridget Riley, Antony Gormley and Francis Bacon. Rodin also features. The gallery is linked by a bridge to the Henry Moore Institute, dedicated to the study of sculpture. (Image courtesy of Paul Dobraszczyk)

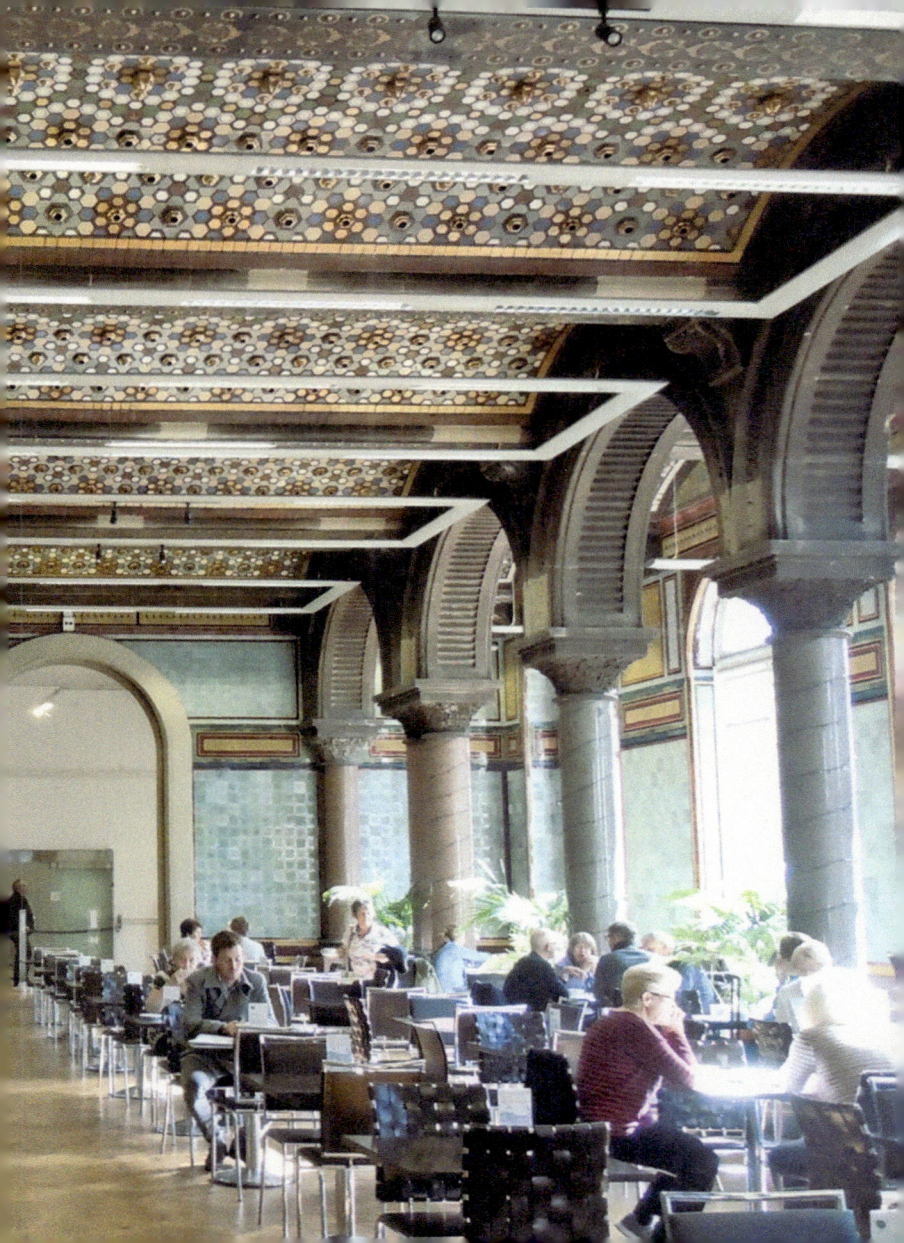

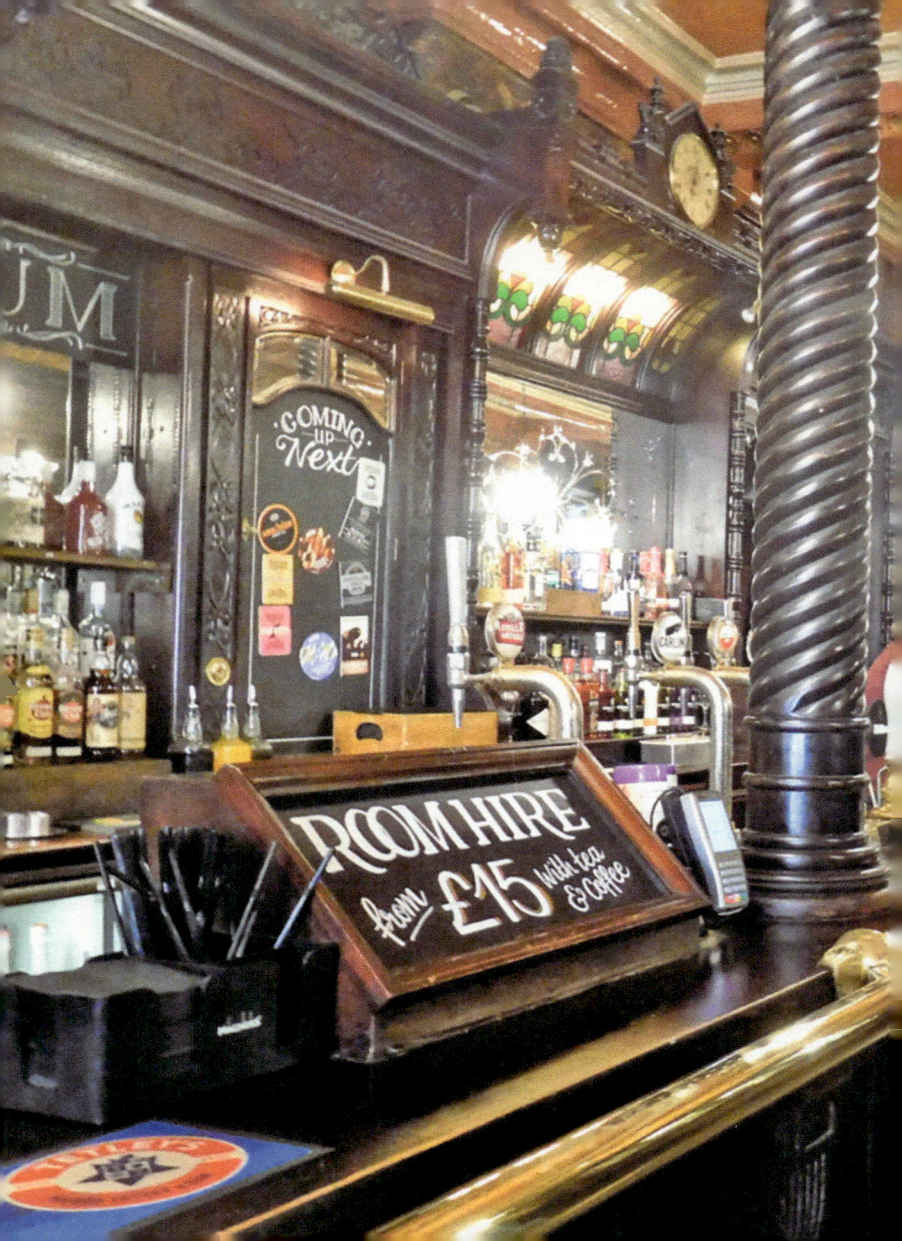

21. THE VICTORIA FAMILY & COMMERCIAL HOTEL, GREAT GEORGE STREET

Behind the Town Hall, The Vic is TARDIS-like with a large and stunning interior replete with mahogany and etched glass. It had to be saved from demolition by the Leeds public in the 1970s. Built by the Victoria Hotel Company in 1865, when, as the very grand sounding and twenty-eight-bedroom Victoria Family & Commercial Hotel, it catered for those who had business at the Assizes Court in Leeds Town Hall, and for those visiting Leeds General Infirmary. This grand pub was connected to the Town Hall by an underground passage.

Its name remains in beautiful gilt lettering above the front door, and from Great George Street you enter a magnificent high-ceilinged lobby from where doorways lead to the Vic's three distinct drinking areas. The wooden panelling, gilt mirrors and ornate light fittings that have long marked this place as different are all still there. Bridget's Bar, to the left, with its sumptuous décor and comfortable furnishing feels as welcoming as ever. Across the hallway is the main bar, whose etched glass and cosy booths offer that same familiar feel. (Simon Jenkins, *Yorkshire Evening Post,* 13 December 2018)

Sadly, Covid-19 may have dealt a fatal blow to this magnificent pub and it remains closed for the forseeable future.

22. LEEDS GENERAL INFIRMARY

The General Infirmary at Leeds (its old official name) dates back to June 1767 when an infirmary 'for the relief of the sick and hurt poor within this parish' was set up in a private house in Kirkgate. Four years later, the General Infirmary's first purpose-built building opened near City Square in Infirmary Street on the site of the former Yorkshire Bank. The five founding physicians were all graduates of the University of Edinburgh Medical School.

The infirmary has continued to expand ever since, resulting in the move to this site on Great George Street in 1869. It has magnificent buildings designed by Sir George Gilbert Scott. The Finsen Light Room at Leeds General Infirmary was established in 1901 when a dermatology department was completed. The Finsen lamp was developed by Danish physician Niels Ryberg Finsen, who discovered the therapeutic effects of ultraviolet rays for certain conditions of the skin, in particular lupus vulgaris, a tuberculous skin disease. The treatment was successful and, by 1903, three lamps were in use, with sixty patients a day being treated.

No. 9 Ward, Leeds Infirmary.

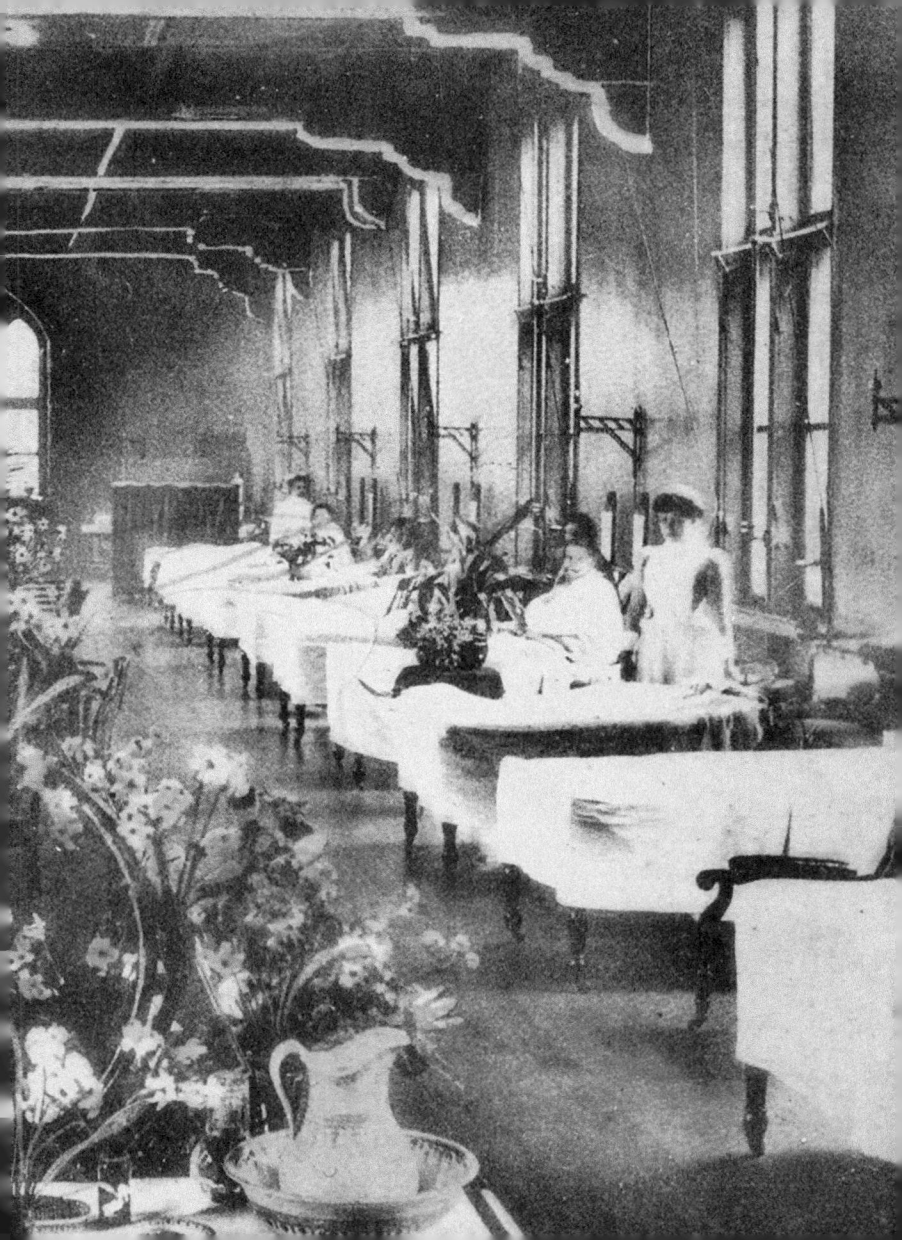

23. THE MECHANICS' INSTITUTE (NOW CITY MUSEUM)

Leeds Mechanics' Institute (1824) was built by Cuthbert Broderick. The objective of the Mechanics' Institute was to maintain a technical education for the working man and for professionals to 'address societal needs by incorporating fundamental scientific thinking and research into engineering solutions'. They effectively transformed science and technology education for the man in the street. A number have become cutting-edge universities or similar centres of excellence. Leeds is a case in point. In 1846, the Leeds Mechanics' Institute was already offering drawing classes when it merged with the Literary Institute, creating Leeds School of Art. In 1868, Leeds Mechanics Institute became the Leeds Institute of Science, Art and Literature. In 1903, it moved to the Vernon Street building, the radical design of which reflected the Art and Crafts movement. Henry Moore and Barbara Hepworth are among the alumni, enrolling in 1919 and 1920 respectively. When the Mechanics' Institute stopped educating it became a concert hall, known as the Civic Theatre, and later the City Museum. The new photograph depicts a statue of Circe, the enchantress from Homer's *Odyssey* who detained Odysseus, seduced him and turned his men into swine.

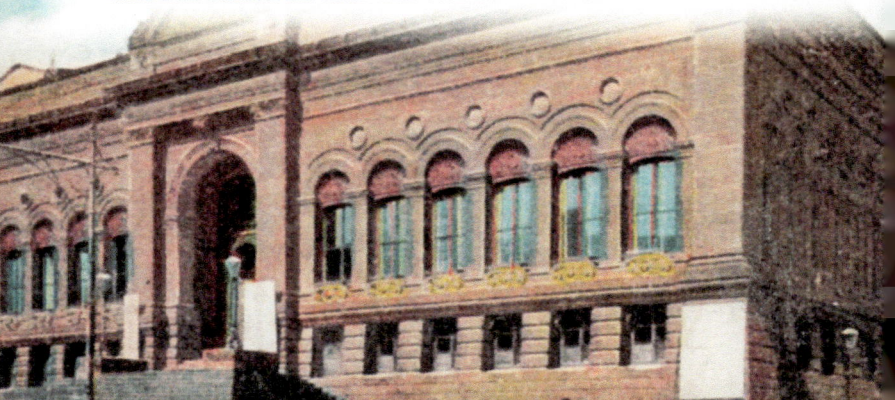

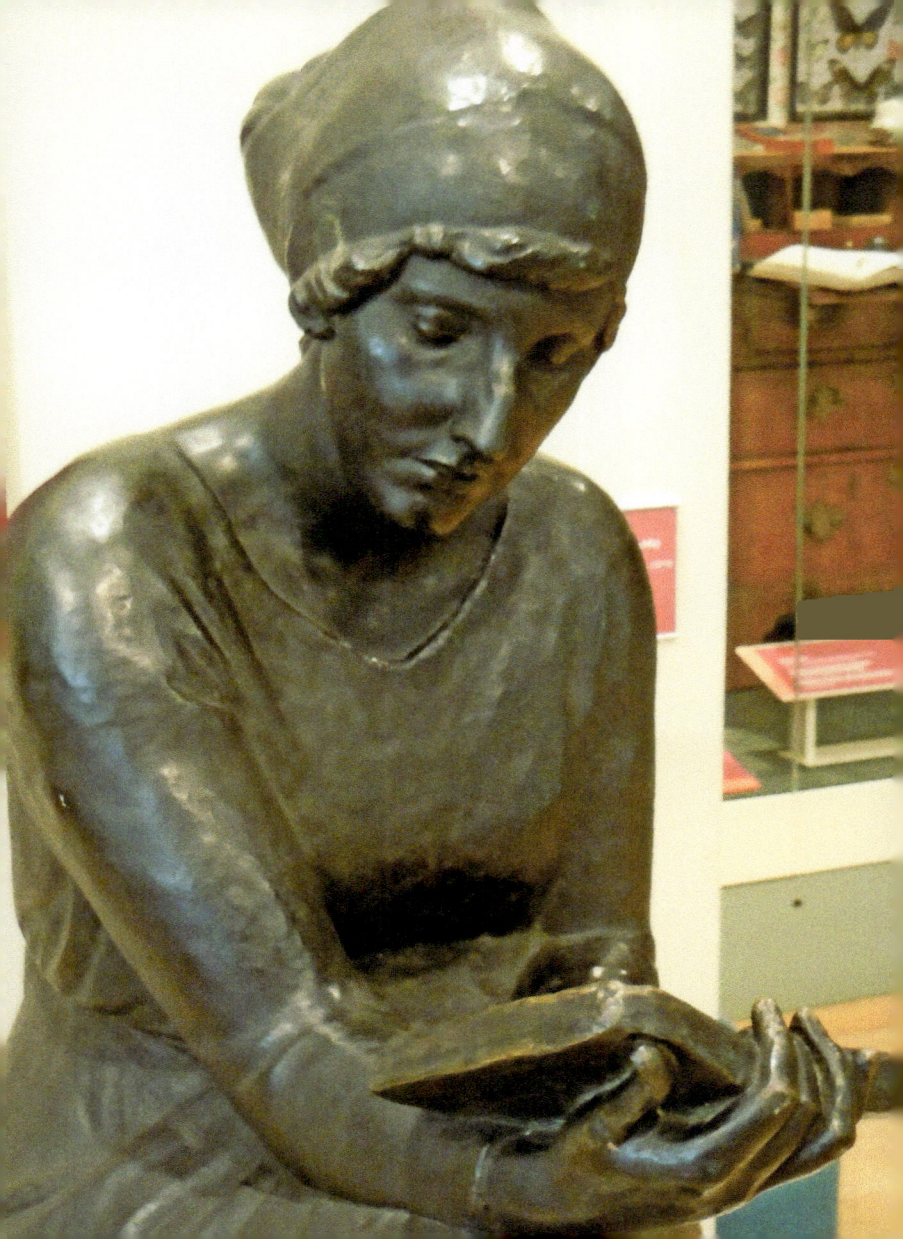

24. DOROTHY UNA RATCLIFFE

A bronze in the City Museum of Dorothy Una Ratcliffe (1887–1967), niece of Lord Brotherton and writer of poetry in the Yorkshire dialect. She is one of the celebrated (but often overlooked) female poets of the First World War, having helped Lord Brotherton equip the Leeds Old Pals Regiment. She also assisted with settling Belgian refugees. Ratcliffe was always an active supporter of the Yorkshire Dialect and Gypsy Lore societies, and remained faithful to the Brotherton Library, to which she donated her collection of Romany material. The Leeds Museum holds her collection of fans and miniatures, and, sadly, baby bonnets – she was unable to bear children thanks to complications from a so-called cure for a sexually transmitted infection caught from her first husband.

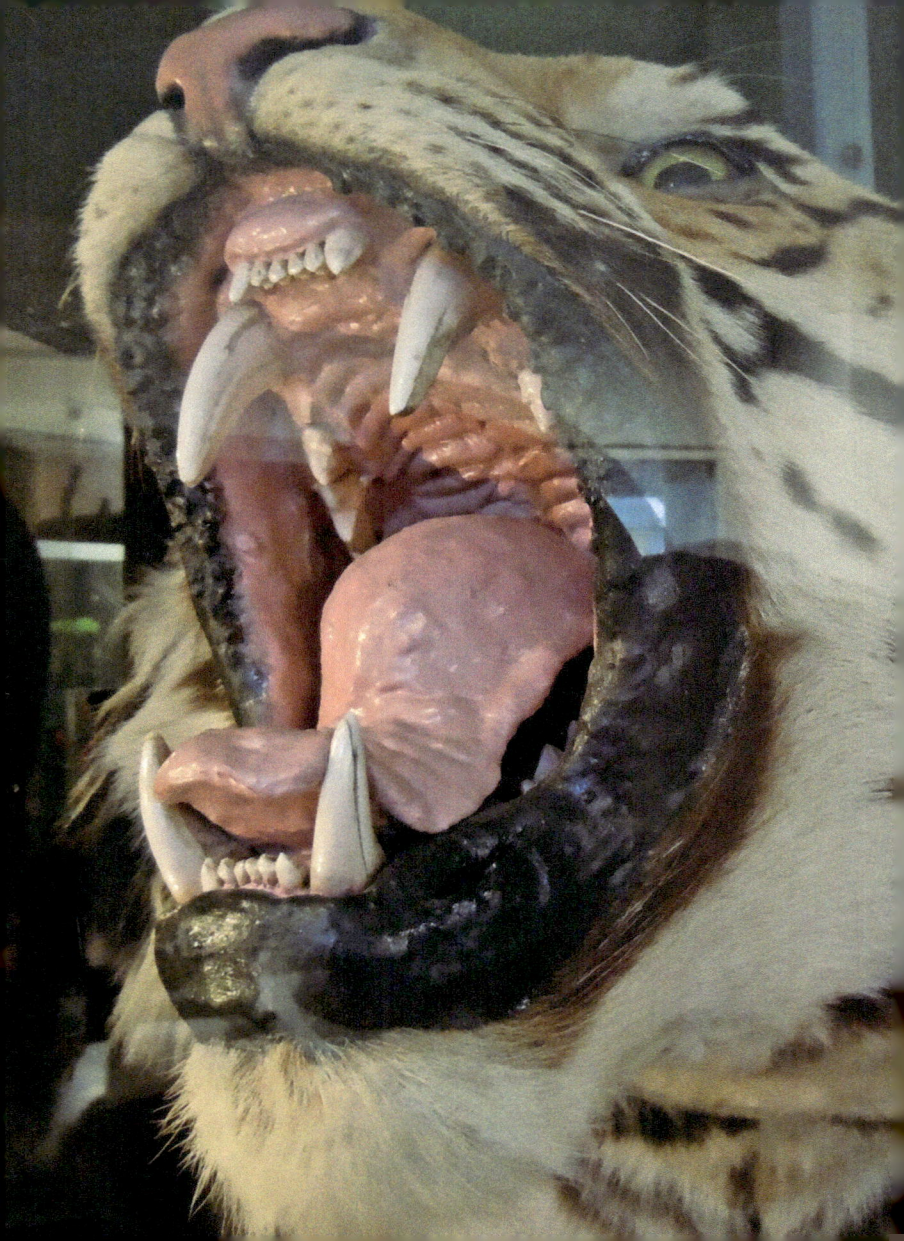

25. LEEDS CITY MUSEUM (1819), PARK ROW AND MILLENNIUM SQUARE

The museum began life in 1819, established on Park Row by the Leeds Philosophical and Literary Society, and opened to the public in 1821. The museum closed in 1965 but reopened in 2008 in the refurbished Mechanics' Institute building. One of the most popular exhibits is the infamous Leeds Tiger. It was saved from the curators' skip by the *Yorkshire Post* when it mounted a successful campaign to retain it as a popular centrepiece of the museum's collection. The Leeds Tiger was originally a tiger-skin rug when presented to the museum in the nineteenth century – the tiger had been shot for taking an unhealthy interest in a village in India. The pelt was then sewn with other tiger skins and, instead of being mounted properly, it was stuffed rather amateurishly with straw. The reputation of and affection for the tiger, meanwhile, escalated. From being just a curious observer of Indian village life, it was elevated to the legendary status of a serial killer of forty villagers.

26. *THE YORKSHIRE POST* BUILDING

The Yorkshire Post, the inner ring road and the Leeds International Swimming Pool feature prominently in this aerial photograph. The photo shows the inner ring road under construction in 1966, with Woodhouse Lane and the old BBC studios on the left with Harewood Barracks. The buildings in the foreground were demolished to make way for what is now Leeds Beckett University.

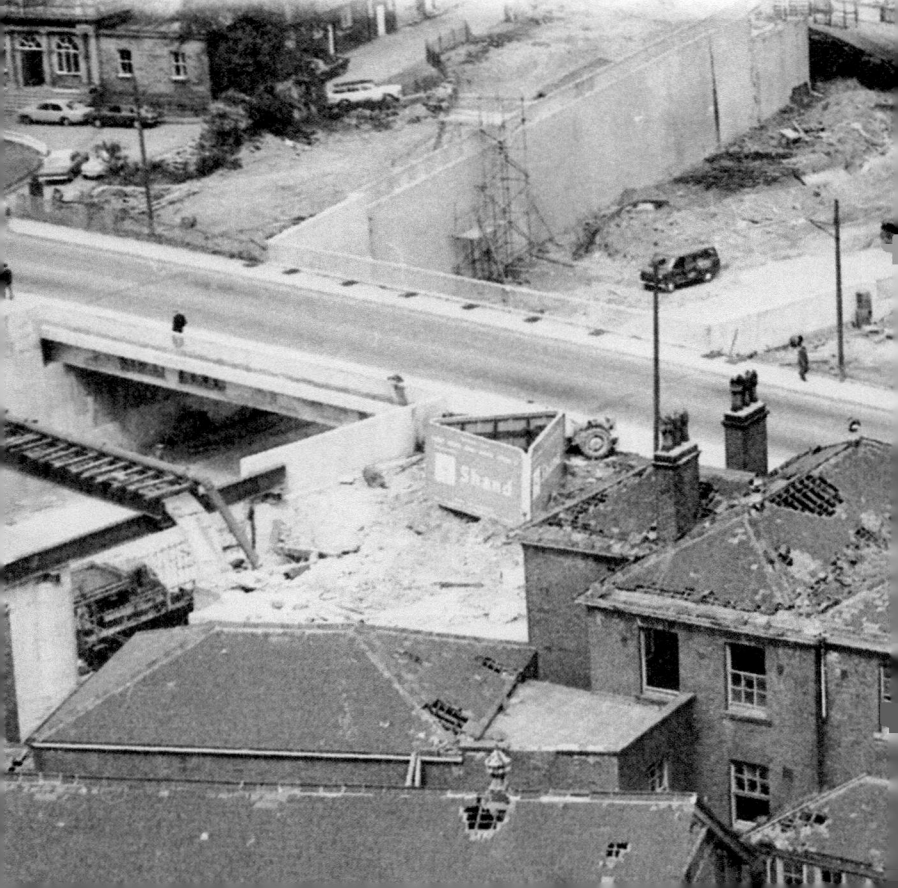

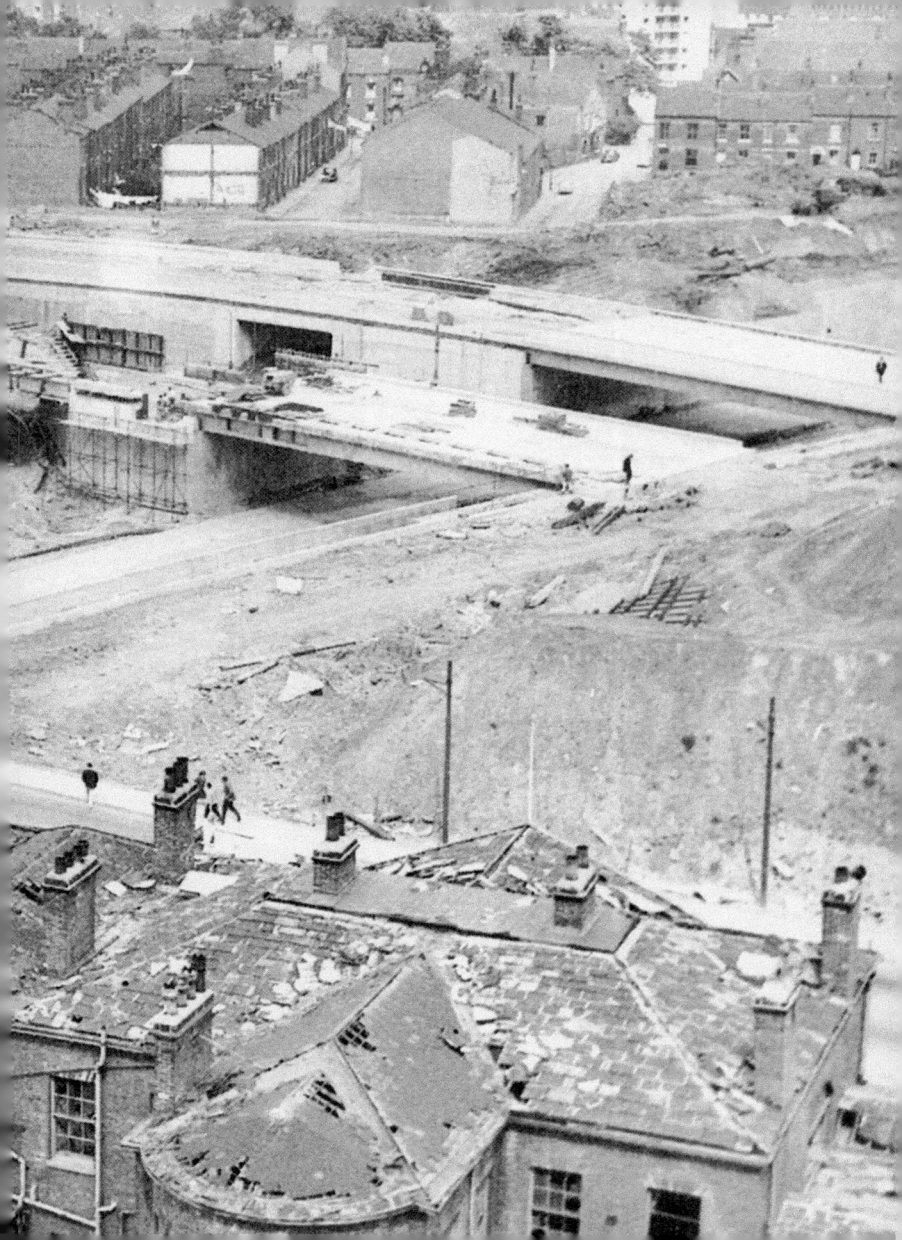

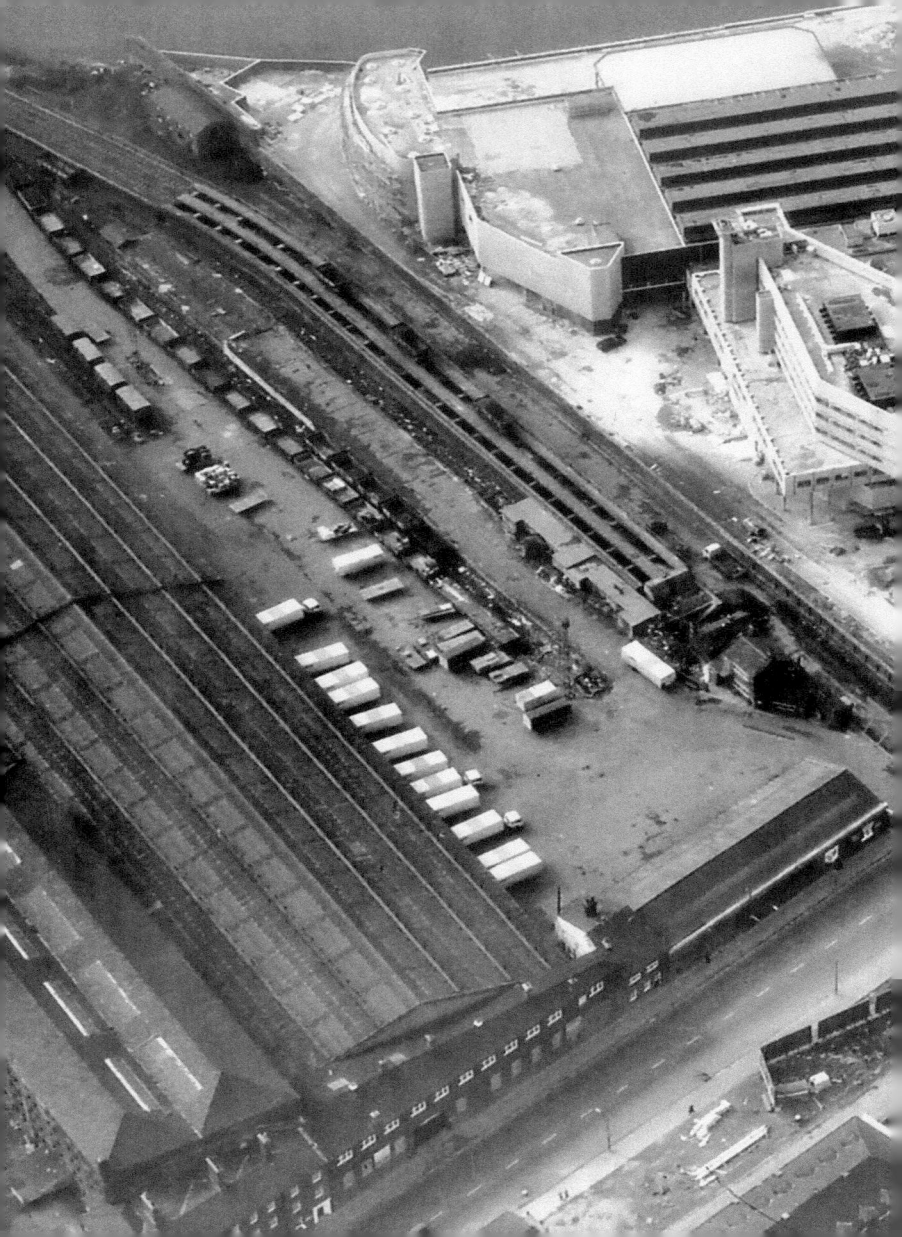

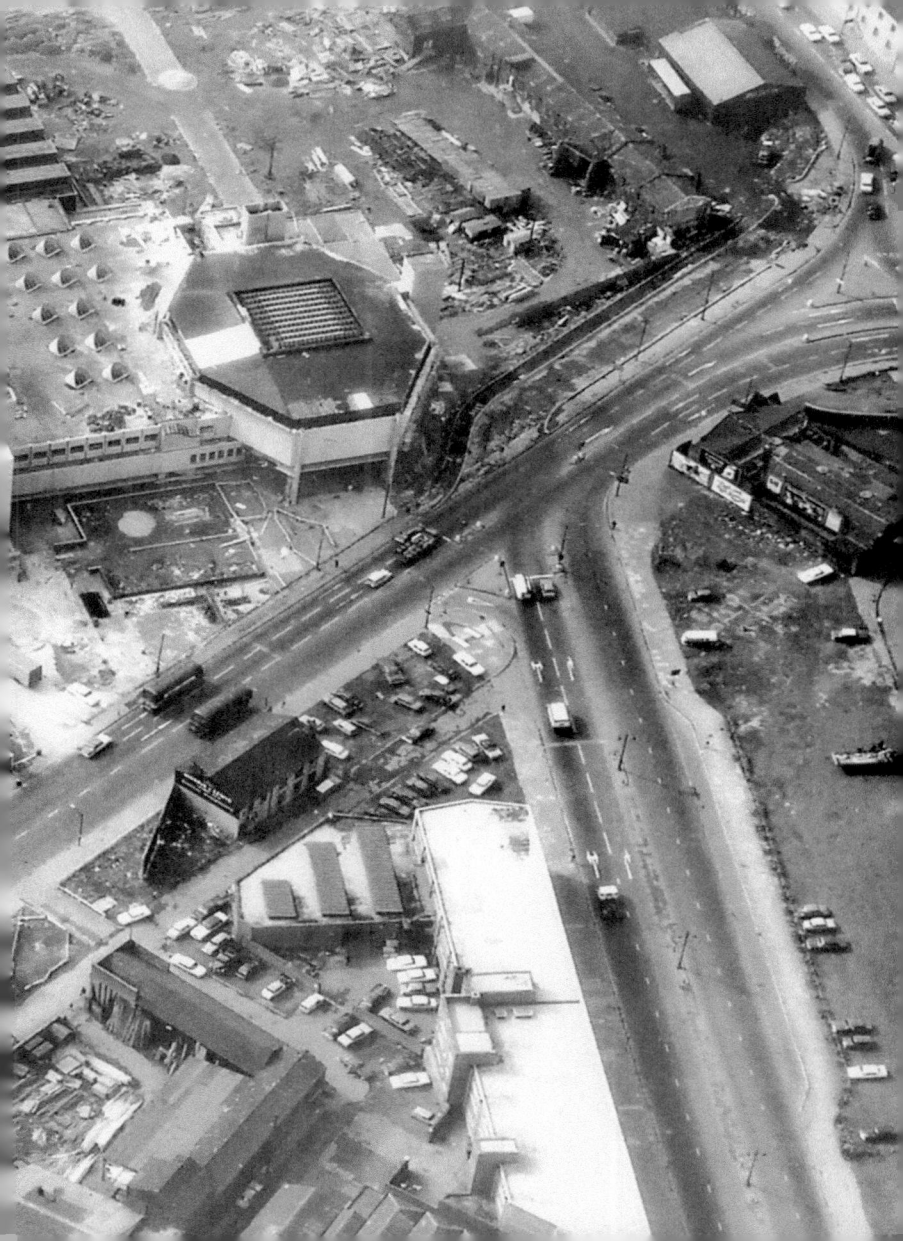

27. BROTHERTON LIBRARY, LEEDS UNIVERSITY

The Brotherton Library in the Parkinson Building is a Grade II listed beaux arts building with art deco fittings, completed in 1936. It is named after Edward Brotherton, who bequeathed £100,000 as funding for the University of Leeds's first purpose-built library in 1927. While the university was still Leeds College it stocked all of the university's books and manuscripts, except the books housed in the separate Medical Library and Clothworkers' Textile Library. The magnificent Reading Room, pictured here, has 6,000 shelves holding 200,000 volumes. In diameter, it is 20 feet larger than the British Museum Reading Room, and there are twenty green Scandinavian marble pillars.

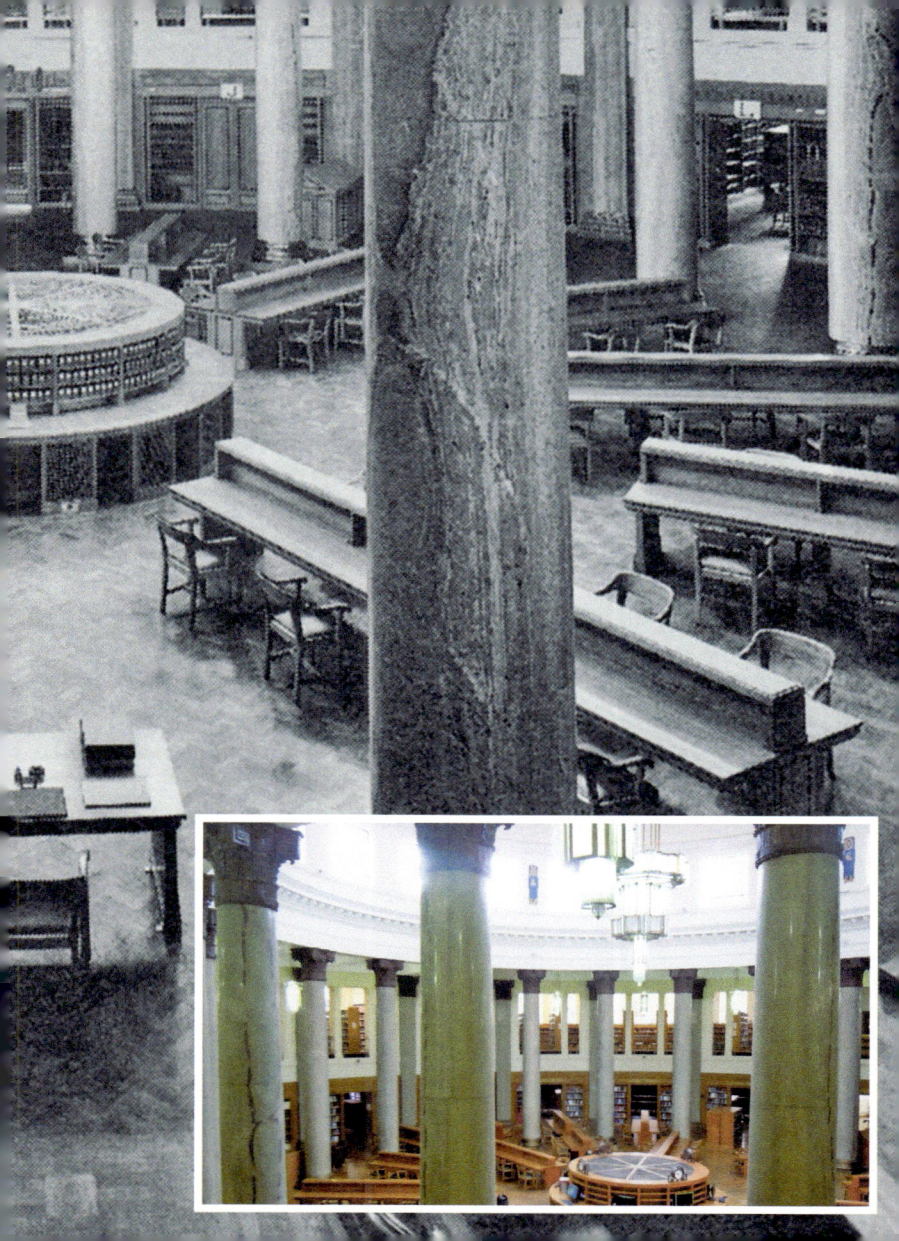

28. THE HYDE PARK PICTURE HOUSE, BRUDENELL ROAD

This Grade II listed picture house started life in 1908 as a hotel and in November 1914 was converted into the cinema, which still retains its nine gas lights, the decorated Edwardian balcony and the original organ and piano. With its 280-seat auditorium, the picture house has kept its two 35-mm film projectors, which are still in use – especially during Leeds International Film Festival, where the cinema serves as a principal venue. The ornate lamp outside the entrance is also Grade II listed, but no longer gas powered. Apart from patriotic films, the picture house also showed the anxious people of Leeds newsreel of the war so they could learn about the 6,000 men from the city who had enlisted. Some were reliant on the picture house news because many of them could not read the newspapers or afford a wireless. (Courtesy of Ollie Jenkins)

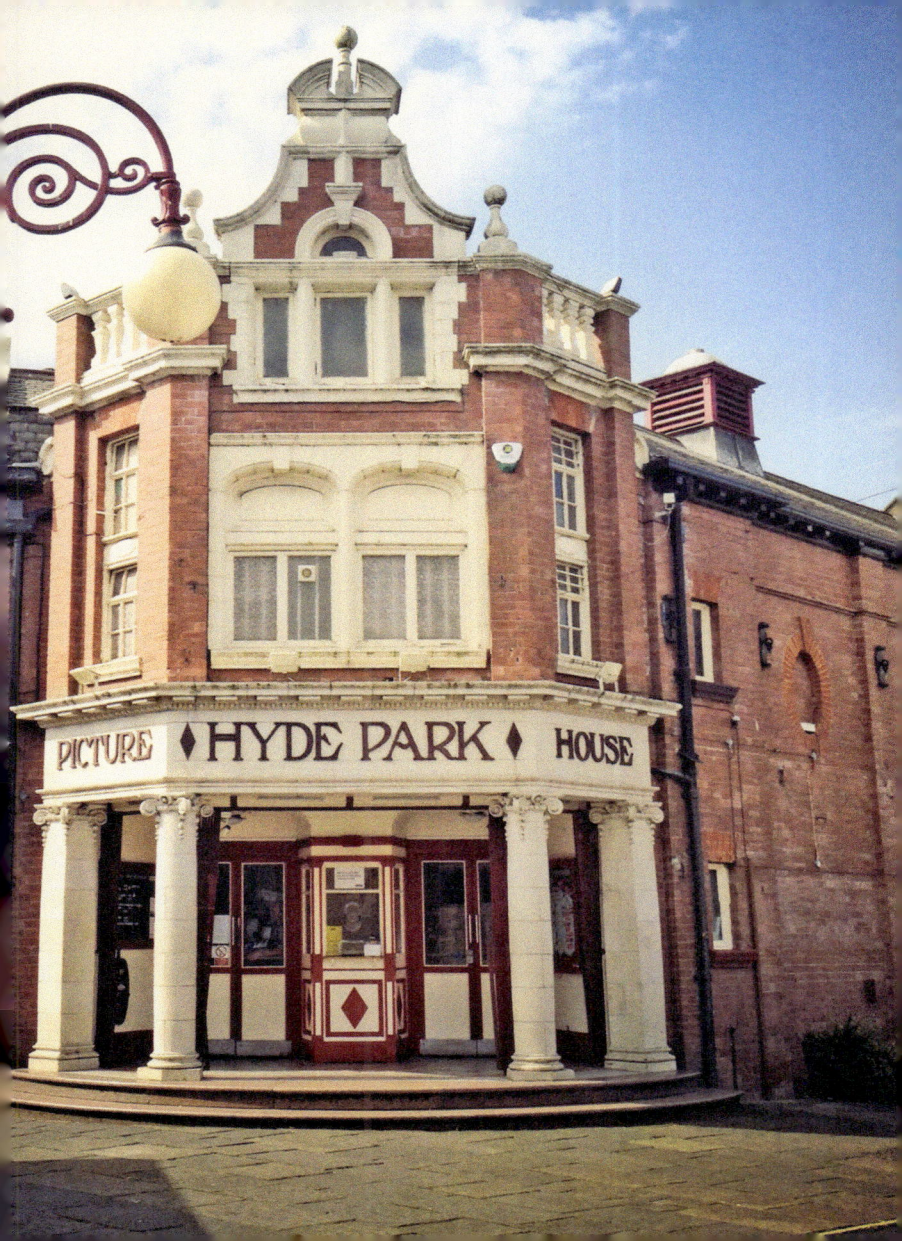

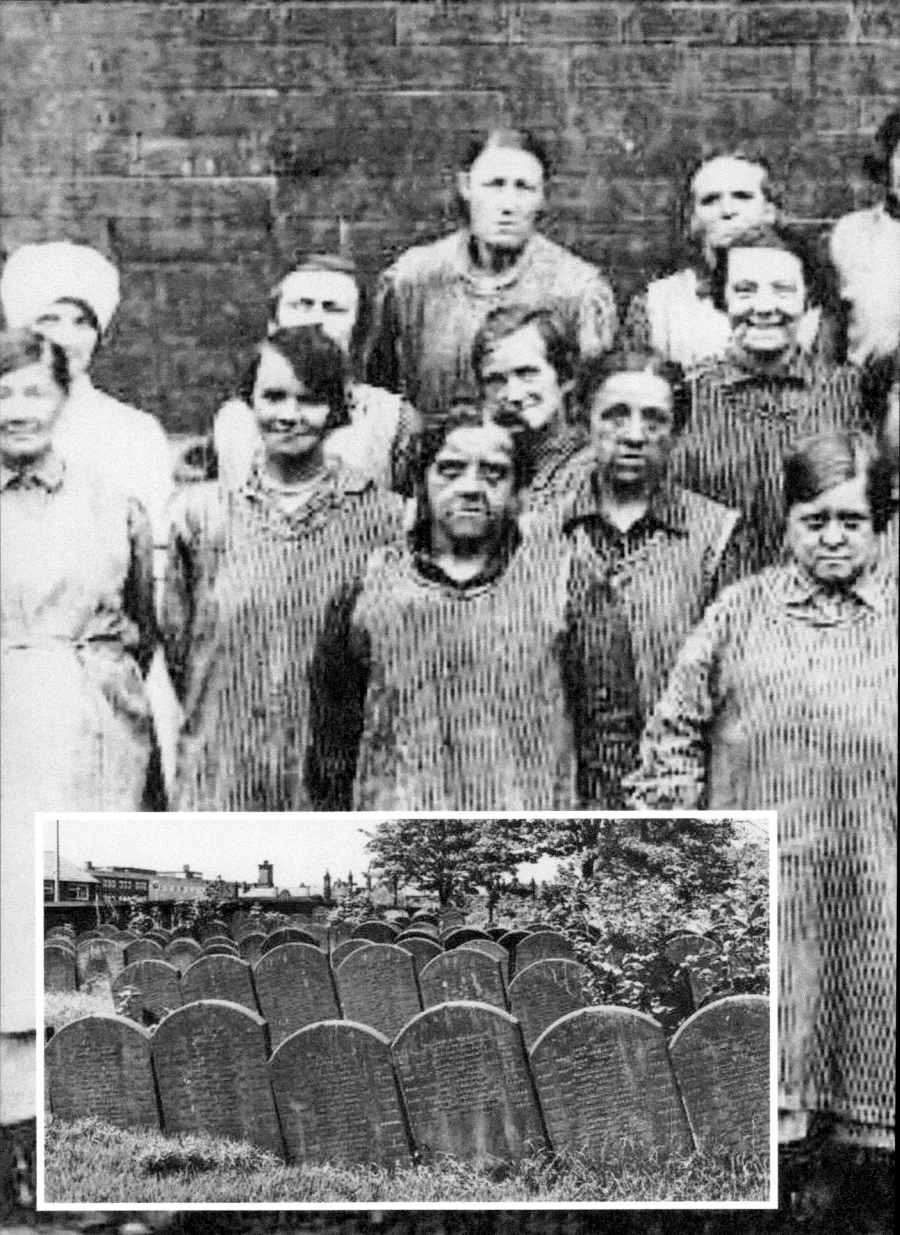

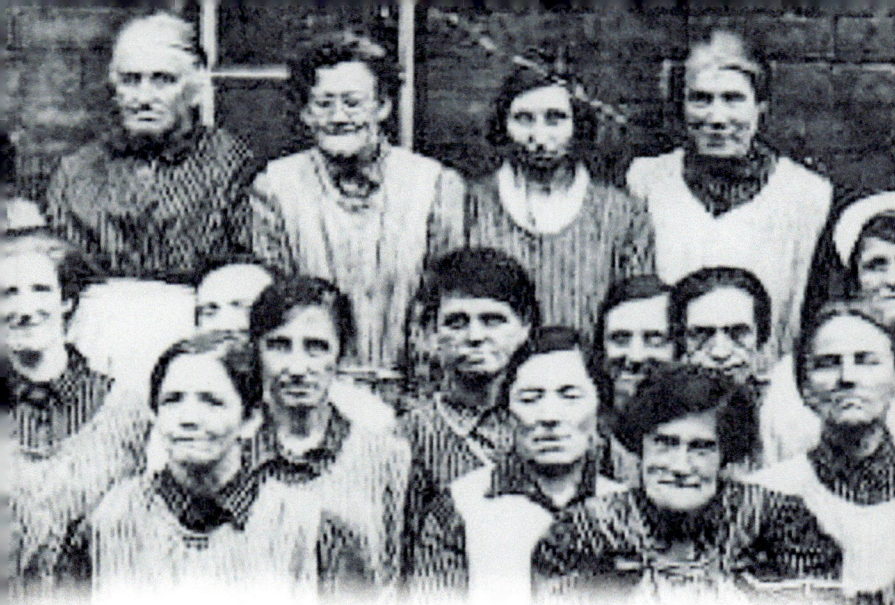

29. LEEDS WORKHOUSE

In theory, the workhouse was intended to provide care and comfort to the most needy and shield them from the worst depredations of life; however, the reality was often very different. These disturbing images show Leeds workhouse female inmates and Leeds workhouse from the cemetery (inset) – the last resting place for many paupers. The building now housing the Thackray Medical Museum opened in 1861 as the first purpose-built Leeds Union Workhouse, accommodating 784 paupers. Over time new buildings were added to the workhouse, including a separate infirmary. In 1848, the Leeds Guardians built the Moral and Industrial Training Schools on the north side of Beckett Street. During the First World War it was called the East Leeds War Hospital, caring for armed services personnel. In 1925, the Leeds Union Workhouse infirmary was repurposed and renamed St James's Hospital. (Courtesy of St James Hospital, Leeds)

30. THACKRAY MEDICAL MUSEUM (1997), BECKETT STREET

A surgical amputation set (1870) that is on display at the Thackray Medical Museum, Leeds.

By the end of the nineteenth century the workhouse buildings were mainly used for medical care of the poor rather than traditional workhouse activity. The reason for this is that Leeds initially opted not to cooperate with the New Poor Law.

Features of the museum include 'Leeds 1842: Life in Victorian Leeds'. This is a walk through slum streets with authentic sights, sounds and smells following the lives, illnesses and treatments of eight Victorians, making choices that determine their survival, or otherwise, among the rats, fleas and bugs. Then there is 'Pain, Pus and Blood', which describes surgery before anaesthesia and advances in pain relief, and finally 'Having a Baby' focuses on developments in childbirth safety. Hannah Dyson's *Ordeal* is a video reconstruction of 1842 surgery, pre-anaesthetics: you watch as a surgeon, his assistant and a group of trainee doctors prepare for Hannah Dyson's operation – the amputation of her leg crushed in a mill accident. (The actual operation is not seen.)

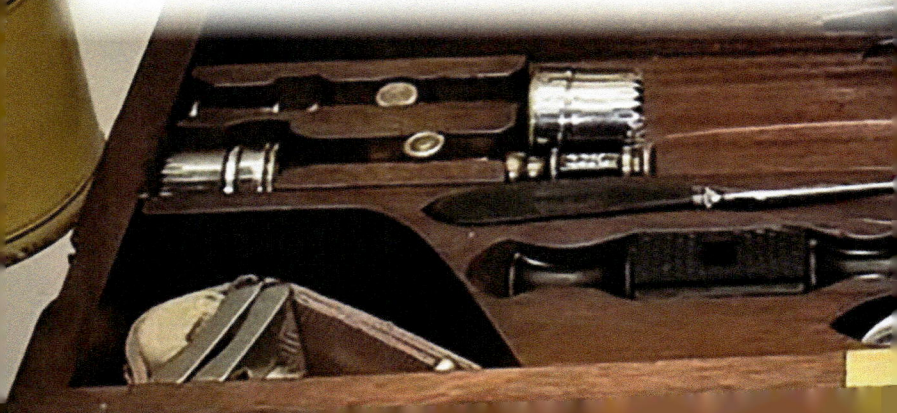

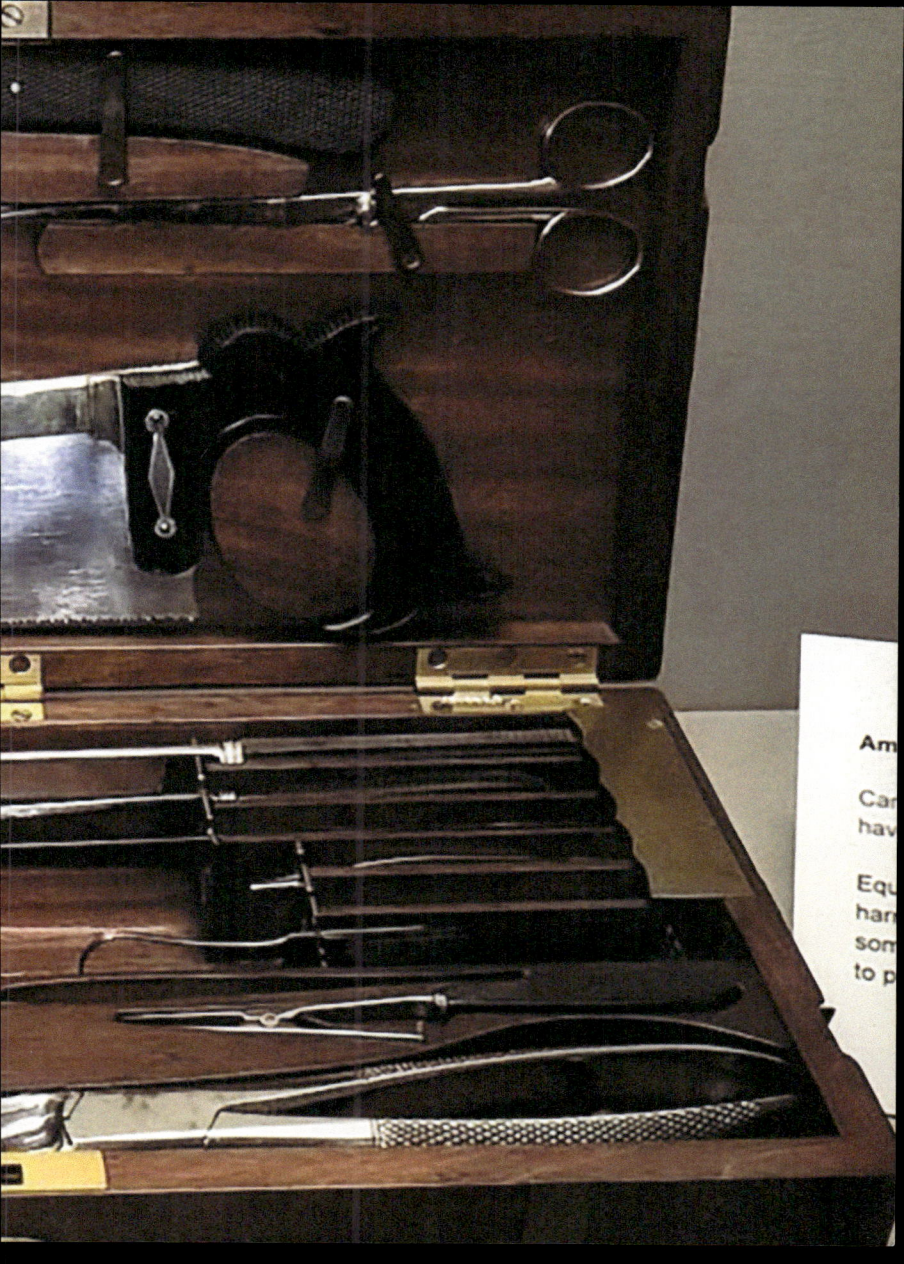

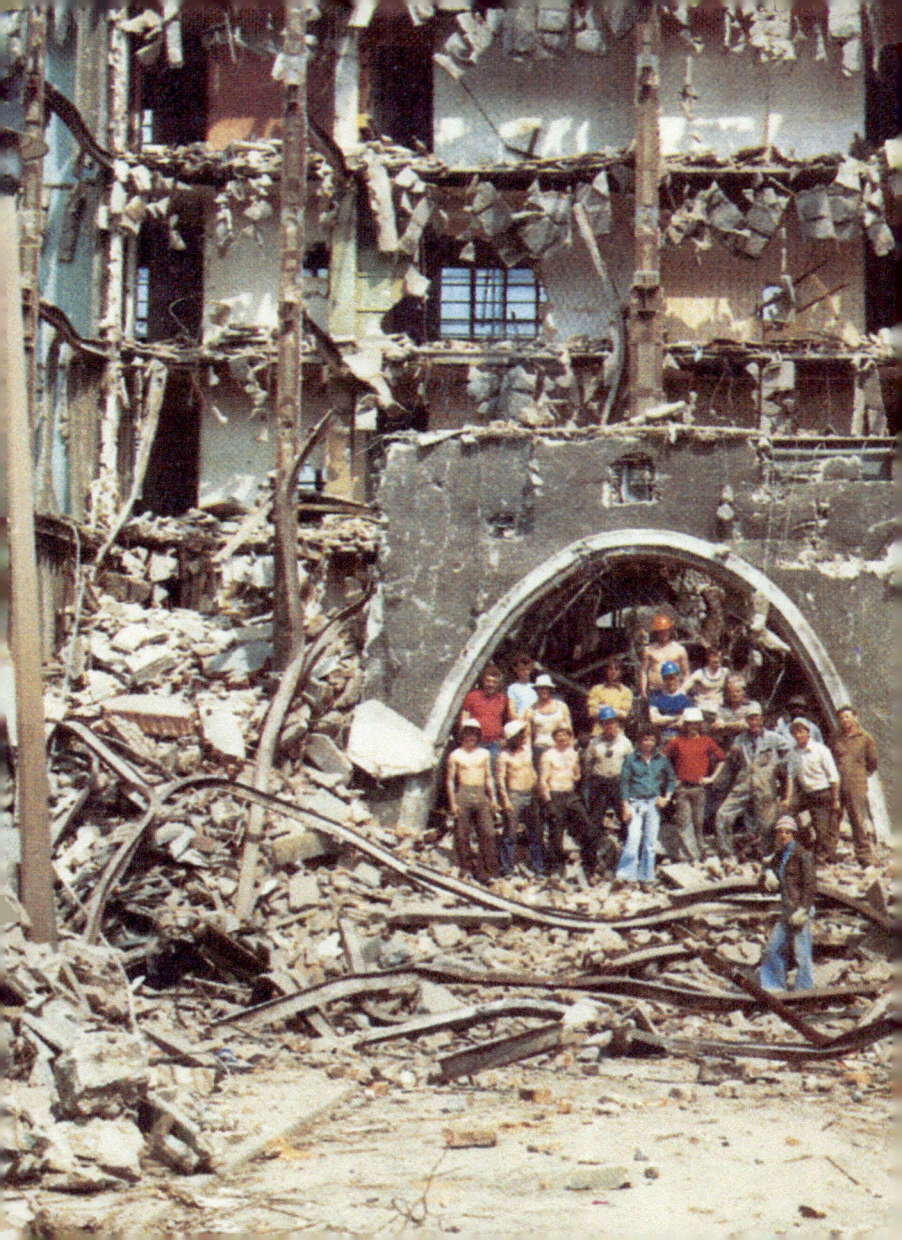

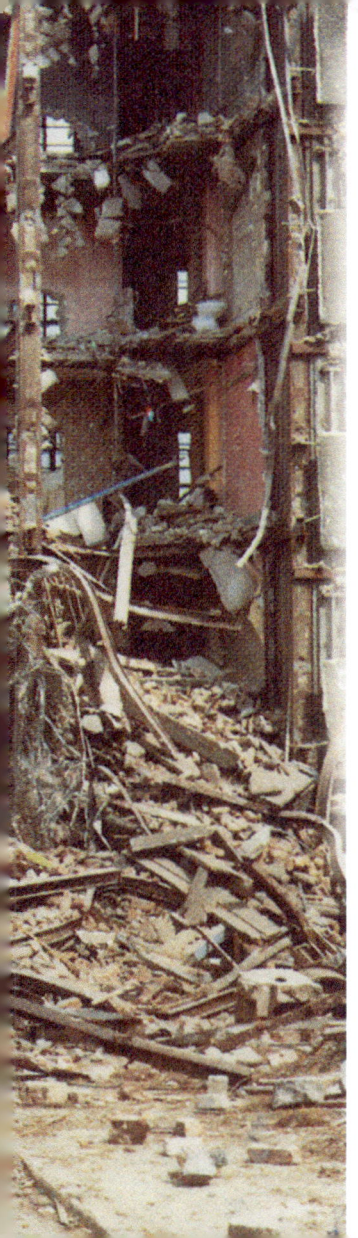

31. QUARRY HILL FLATS, 1939

Between 1938 and 1978, Quarry Hill was the biggest social housing complex in the UK. Its design owed much to such modernist developments as La Cité de la Muette in Paris and the Karl-Marx-Hof in Vienna. The homes at Quarry Hill boasted modern features such as solid fuel ranges, electric lighting, a state-of-the-art (but inefficient) refuse Garchey disposal system and communal facilities. The image overleaf shows Quarry Hill under construction. (Courtesy of Leodis; Leeds Library & Information Services.) The image here shows demolition in full swing in 1978 on a card entitled 'Noel and His Lads'; this was the last standing arch at Quarry Hill. (Courtesy of Peter Mitchell).

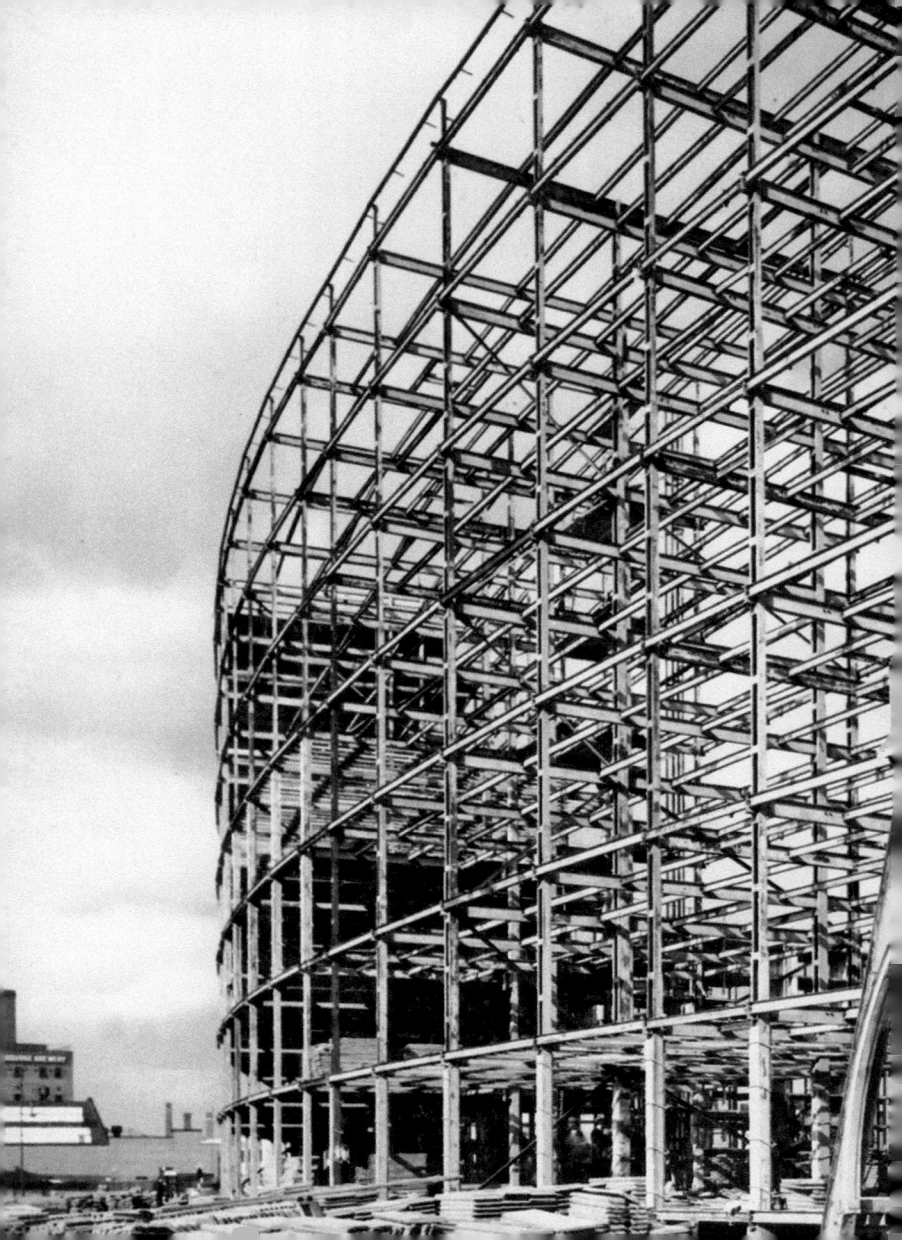

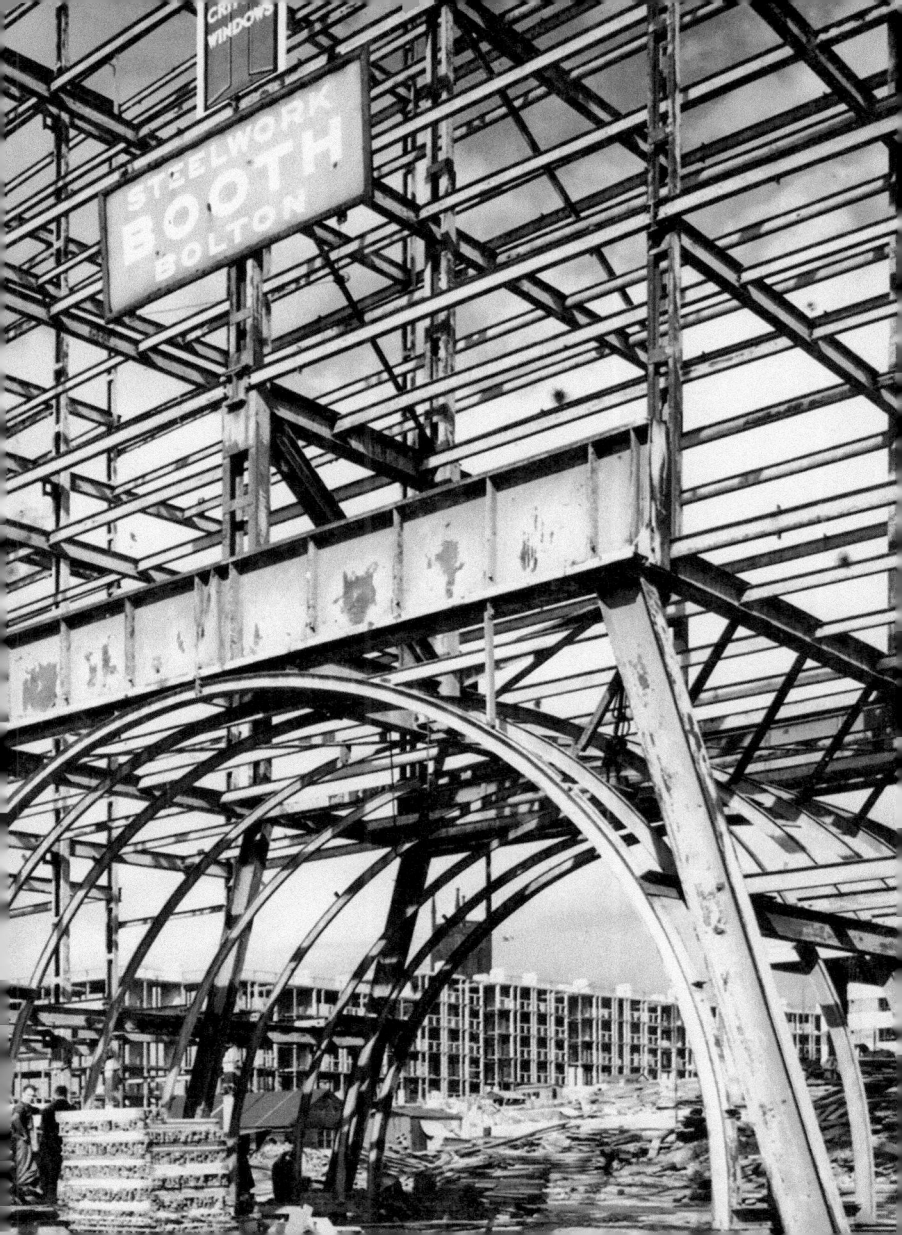

32. AIR-RAID LUXURY IN BURLEY

Mr and Mrs Horace Fawcett relax in their air-raid shelter in Cardigan Avenue, Burley, October 1940 – actually a very comfortable reinforced coal cellar. The Leodis website states: 'The Fawcetts were held up as a shining example of resourcefulness and ingenuity. When members of the ARP came to inspect this shelter, they found the walls neatly papered, electric lighting and a heater installed, chairs and a table, and pictures on the wall, with a cot for the baby in the corner. "It is a grand piece of work" commented Cllr. HW Sellars, ARP chairman.' Many others just moaned about their shelters. (Courtesy of Marc Riboud, 1954, and Leodis; Leeds Library & Information Services)

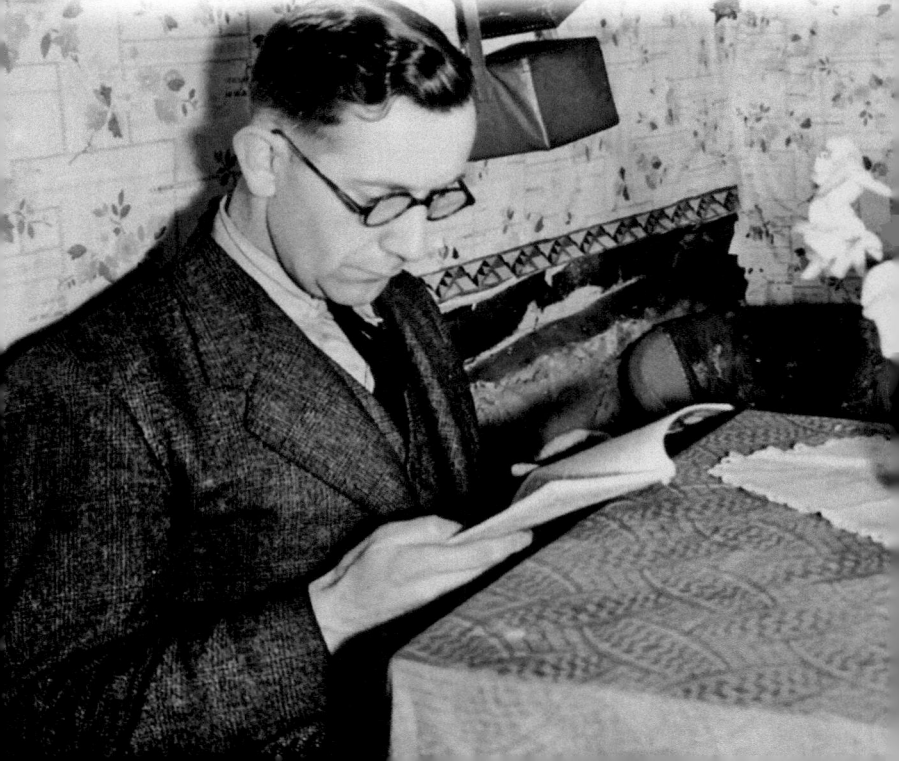

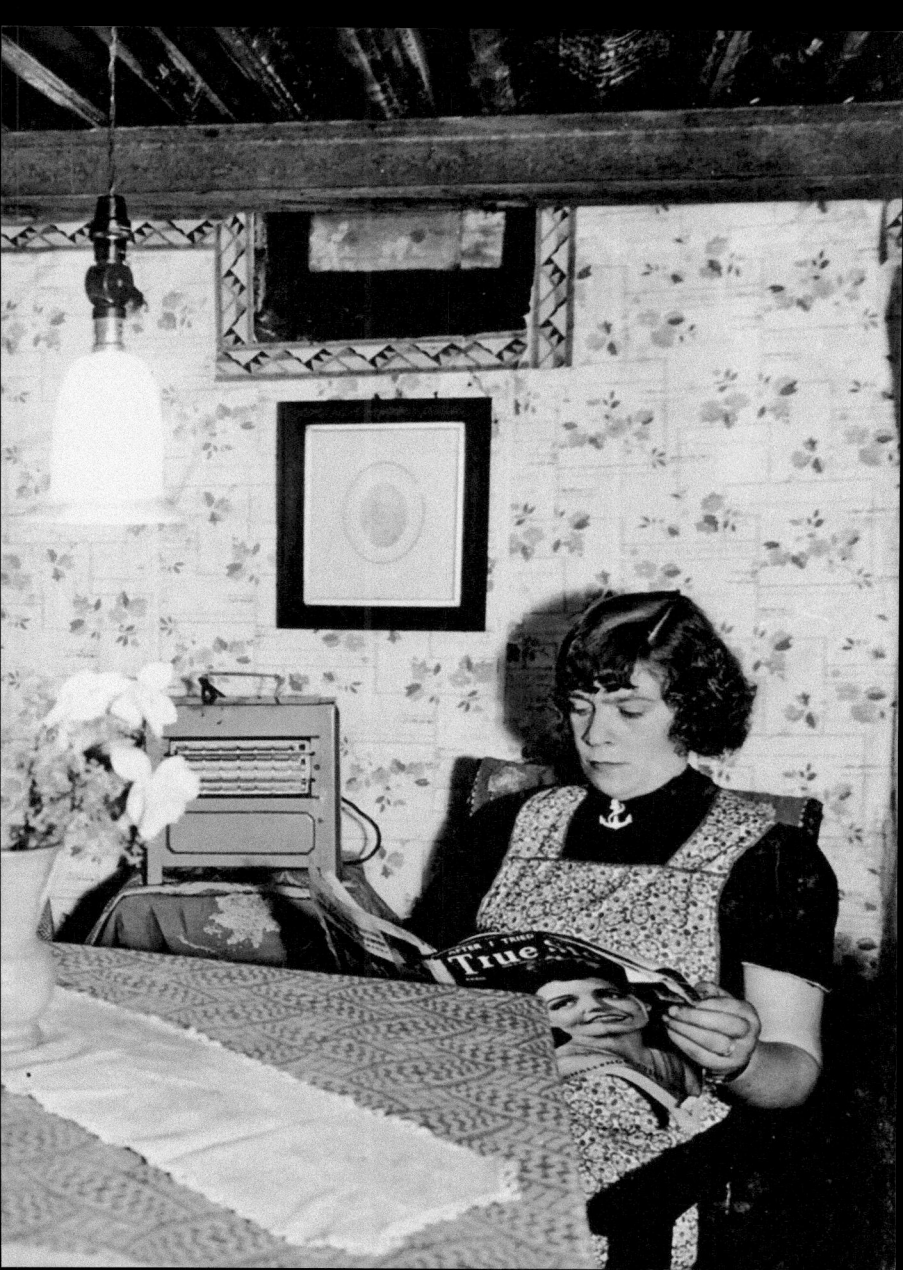

33. BARNBOW LASSES

Barnbow girls making box lids for cartridge-packing cases out of empty propellant boxes. They are using circular saws (without protective guards, of course) to cut the wood to size to make the box lids, the material from waste material.

Barnbow was a First World War munitions factory located between Cross Gates and Garforth, officially known as National Filling Factory No. 1. Sadly, Barnbow is best known for the massive explosion that killed thirty-five of the women workers in 1916. When war was declared, shells were being filled and armed at Leeds Forge Company, Armley, which by August 1915 was filling 10,000 shells every week. This, however, was insufficient to meet demand so a committee, chaired by Joseph Watson (Leeds soap manufacturer), was set up to build a new munitions factory.

Working conditions were nothing short of hell. Workers who handled the explosives stripped to their underwear and wore smocks, caps, rubber gloves and rubber-soled shoes to avoid sparks. Cigarettes

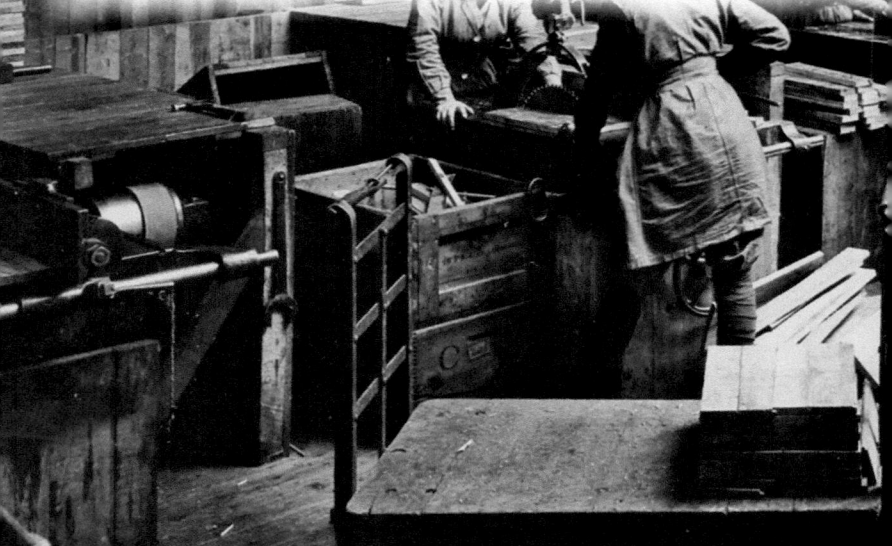

and matches were obviously banned as were combs and hairpins to prevent static electricity. There were no holidays and shifts were eight hours long. Workers were allowed to drink as much barley water and milk as they liked and, to help with the milk, Barnbow had its own farm with a herd of 120 cows producing 300 gallons of milk per day. Working with cordite turned the skin yellow and the only antidote was milk. Because of the yellowness of the women's skin, the women were called the Barnbow Canaries.

On Tuesday 5 December 1916, 170 women and girls had just started their night shift. 4.5-inch shells were being filled, fused and packed in Room 42. At 10.27 p.m., there was a massive explosion that killed thirty-five women outright and maimed and injured many more. Many of the dead were only identifiable by their identity disks. None of this was made public until 1924; at the time, death notices appeared in the *Yorkshire Evening Post*, simply stating cause of death as 'killed by accident'. (Courtesy of Leodis; Leeds Library & Information Services)

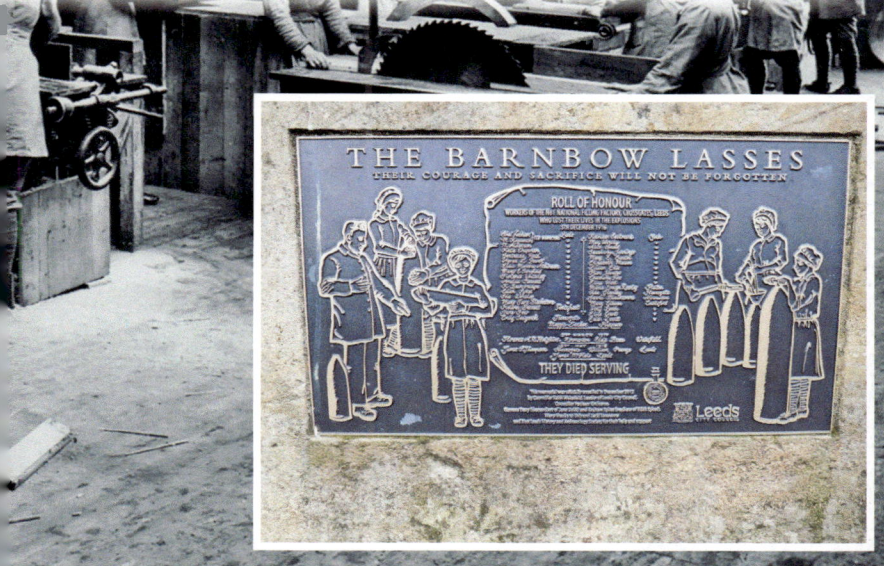

34. ATTENTION!

Children working hard with their teachers and, overleaf, children standing to attention in lines for an assembly in the Central Hall at Darley Street Board School. Teachers are at the back keeping an eye on this infant class. (Courtesy of Leodis; Leeds Library & Information Services)

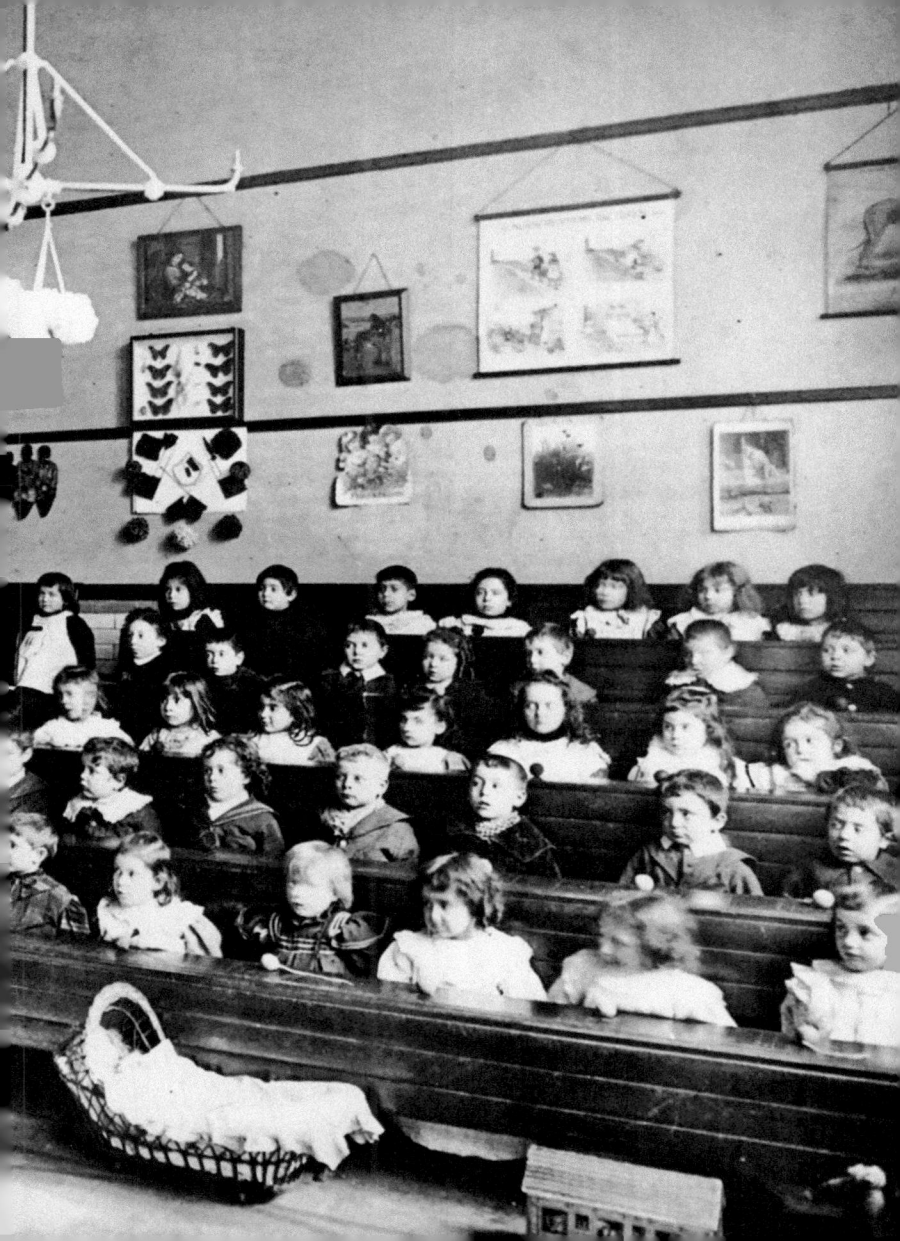

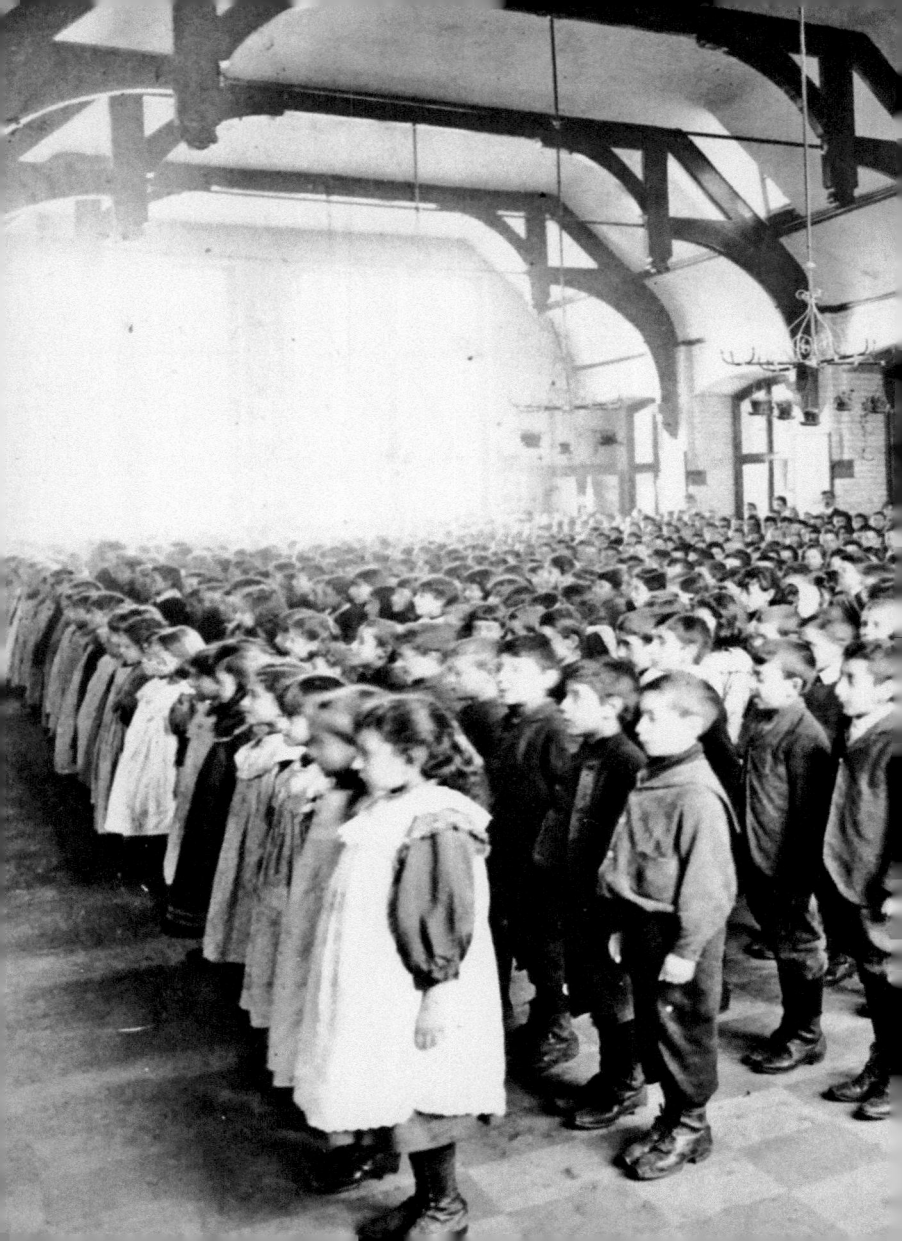

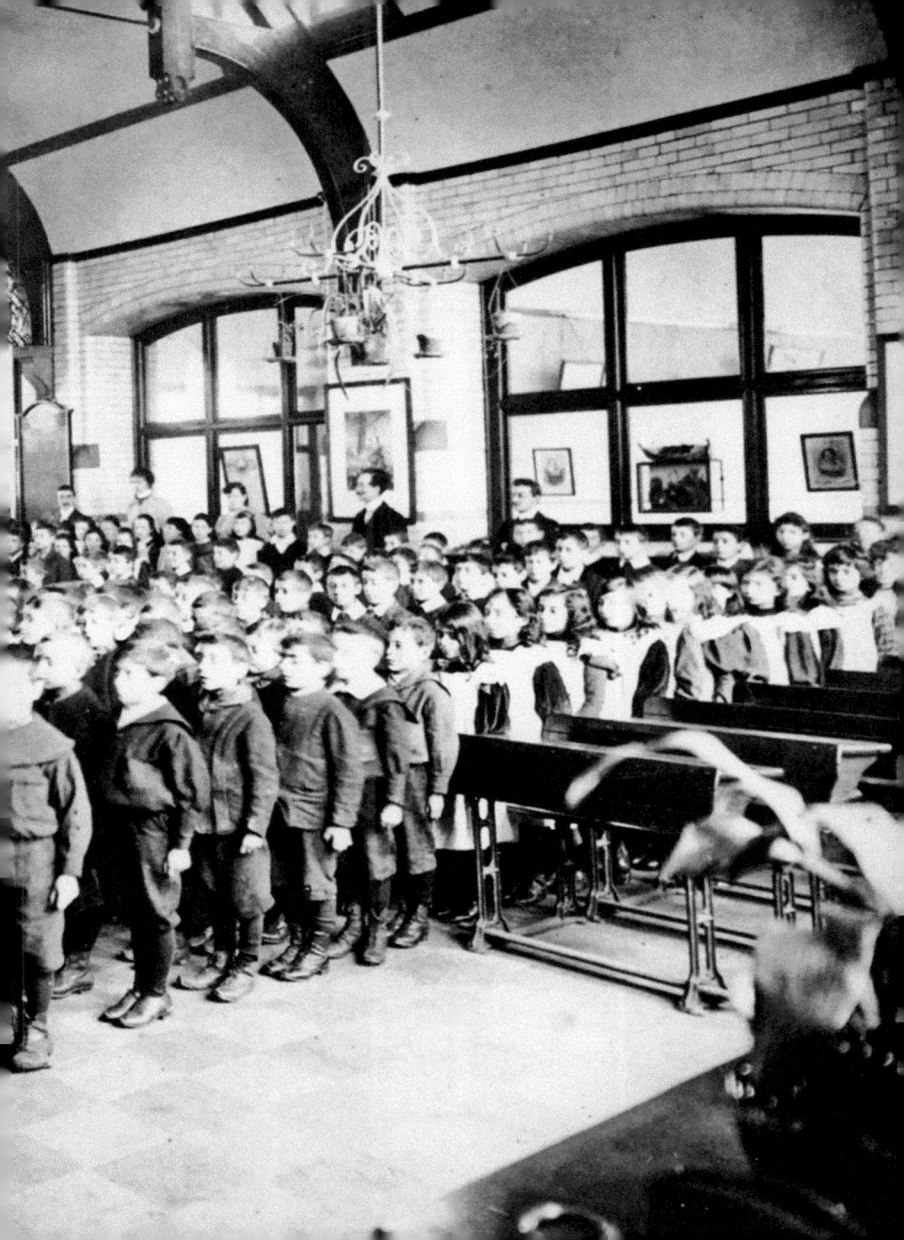

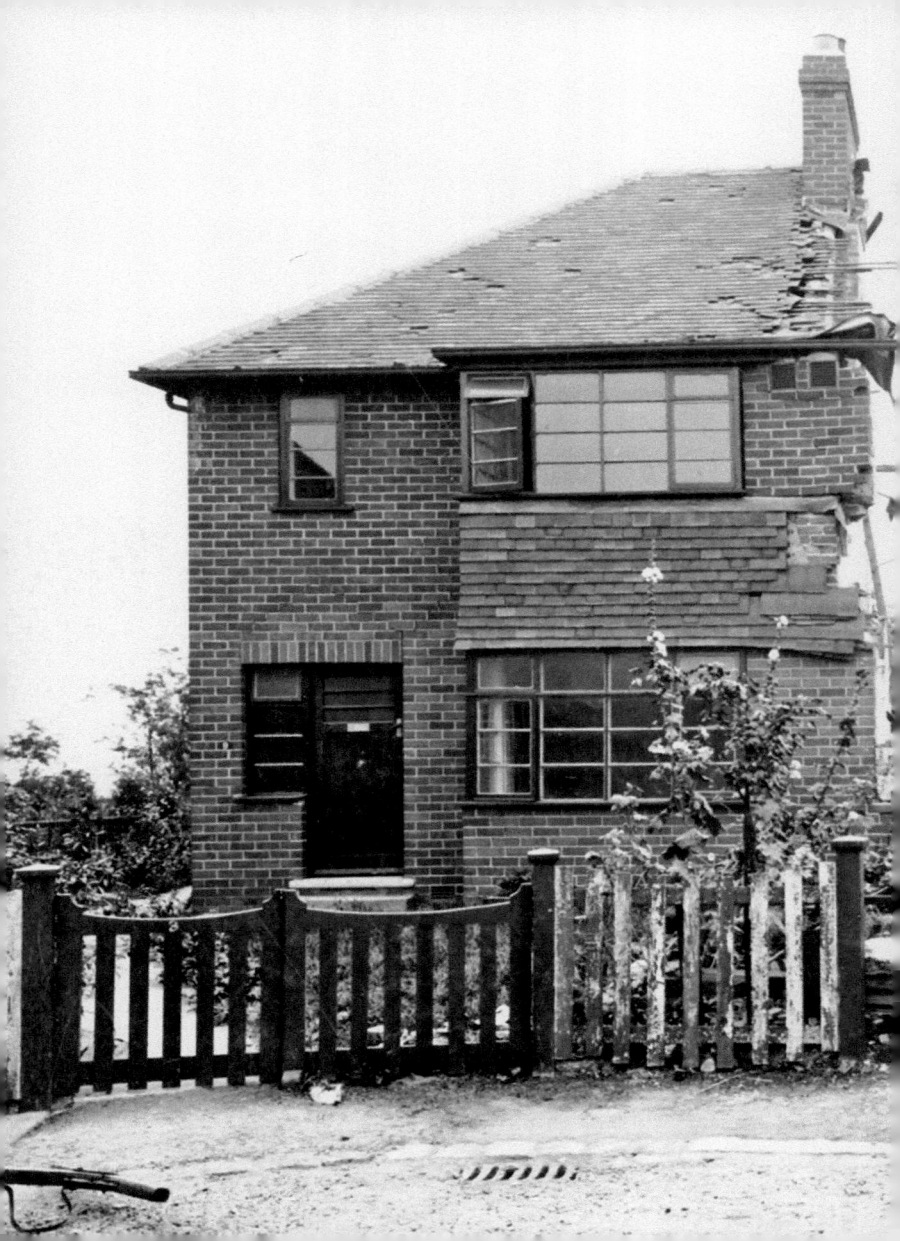

35. INSTANTLY DETACHED

During the Second World War seventy-seven Leeds people were killed and 327 injured in nine raids. A total of 7,623 houses were destroyed and 197 other buildings. The photo shows how the Luftwaffe, with typical precision and efficiency, neatly converted this semi into a detached house on 22 September 1941 in a cul-de-sac off Cliff Road. Apparently, the owners had taken shelter in next door's cellar because they themselves did not have one. (Courtesy of Leodis; Leeds Library & Information Services)

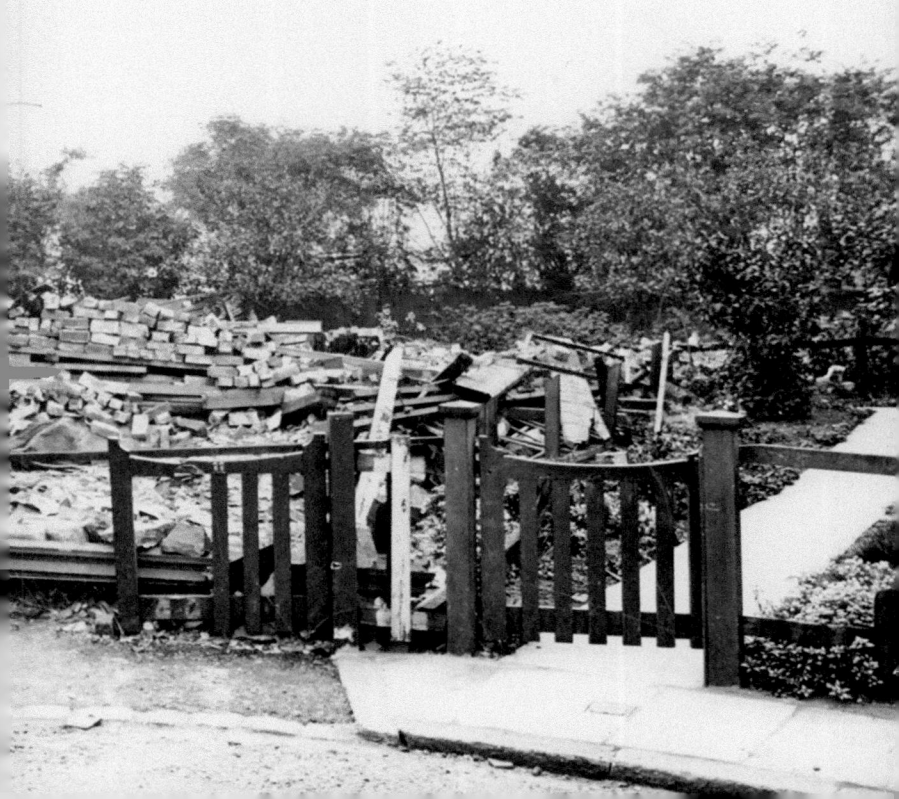

ACKNOWLEDGEMENTS

As with my other books on Leeds, the people of Leeds have been very supportive and generous in the help they have given in the compilation of this new book. Without them the book would be considerably less informative and significantly less colourful. I would, therefore, like to thank the following for their assistance in the provision of information and photography: Anys Williams at Anita Morris Associates for the Corn Exchange images; Sally Hughes, Assistant Librarian Manager, Local and Family History Library; Leeds Central Library for the Leodis images; Peter Higginbotham, workhouses.org.uk; Ollie Jenkins, Picture House Administrator, Hyde Park Picture House; Andrew Bannister, Head of Media Relations; and Leeds Teaching Hospitals NHS Trust.

Websites

aireboroughcivicsociety.org.uk

ancestry.com

archives.wyjs.org.uk

barwickinelmethistoricalsociety.com

bbc.co.uk

bigbookend.co.uk

cix.co.uk

elhas.org.uk

gravestonephotos.com

gsal.org.uk

leeds.ac.uk

leodis.net

nationalarchives.gov.uk

paulchrystal.com

teshno.com

thoresby.org.uk

tithemaps.leeds.gov.uk

theleedswarehouse.com

workhouses.org.uk

yayas.org.uk

yfaonline.com

ABOUT THE AUTHOR

Paul Chrystal was educated at the universities of Hull and Southampton where he took degrees in Classics. For the past thirty-five years he worked in medical publishing, much of the time as an international sales director for one market or another.

More recently he has been history advisor to local visitor attractions such as the National Trust in York and 'York's Chocolate Story', writing features for national newspapers and broadcasting widely on Talk Radio, BBC local radio, on Radio 4's PM programme and on the BBC World Service.

He is contributor to a number of history and archaeology magazines and the author of over 120 books published since 2010 on a wide range of subjects including classical and social history, histories of chocolate, coffee, sweets and tea, BAOR, the Troubles, and many local histories.

He is a regular reviewer for and contributor to *Classics for All*. He has contributed to a six-part series for BBC2 'celebrating the history of some of Britain's most iconic craft industries'. He is an editorial advisor for the Yale University Press classics list and a contributor to the classics section of *Bibliographies Online*, published by Oxford University Press.

In 2019 he took over the history editorship of *Yorkshire Archaeological Journal*, the journal of the Yorkshire Archaeological and Historical Society. Also in 2019 he was guest speaker for Vassar College New York's London Programme in association with Goldsmith University. In 2021 he assisted in the research for an episode of *Who Do You Think You Are?*, which is to be aired in 2022.

Paul is married with three children and lives near York.

By the Same Author

Leeds Pubs (2020)
The Romans in the North of England (2019)
A–Z of Leeds: Places, People, History (2019)
Yorkshire Literary Landscapes (2018)
Yorkshire Murders, Manslaughter, Madness & Executions (2018)
Leeds's Military Legacy (2017)
Leeds in 50 buildings (2016)
Central Leeds Through Time (2016)
The History of Sweets (2021)
A History of the World in 100 Pandemics, Plagues & Epidemics (2021)
Old Bramley and Stanningley (2021)
For a complete list please visit www.paulchrystal.com.

Also by Amberley

A fascinating tour of Leeds' pub scene, charting the city's taverns, alehouses and watering holes, from past centuries to more recent times.
978 1 4456 9688 1
Available to order direct 01453 847 800
www.amberley-books.com

Explore the city of Leeds in this fully illustrated handy
A-Z guide to its history, people and places.
978 1 4456 8913 5
Available to order direct 01453 847 800
www.amberley-books.com

Using images from the Historic England archive, complemented with the author's own, this is a beautifully illustrated history one of England's finest cities.

978 1 4456 7610 4

Available to order direct 01453 847 800

www.amberley-books.com